LADAKH

Heaven in the Himalayas - A *piece of broken* Moon-land in India

A portraiture through lens : First Part

Deb Lahiri

PARTRIDGE

Copyright © 2019 by Deb Lahiri.

ISBN: Softcover 978-1-5437-0598-0
eBook 978-1-5437-0597-3

All rights reserved. No part of this book may be used or reproduced by any means, graphic, electronic, or mechanical, including photocopying, recording, taping or by any information storage retrieval system without the written permission of the author except in the case of brief quotations embodied in critical articles and reviews.

Because of the dynamic nature of the Internet, any web addresses or links contained in this book may have changed since publication and may no longer be valid. The views expressed in this work are solely those of the author and do not necessarily reflect the views of the publisher, and the publisher hereby disclaims any responsibility for them.

Print information available on the last page.

To order additional copies of this book, contact
Partridge India
000 800 10062 62
orders.india@partridgepublishing.com
www.partridgepublishing.com/india

To,
My mother Jayanti Lahiri
My daughter Sreedatri Lahiri

vi

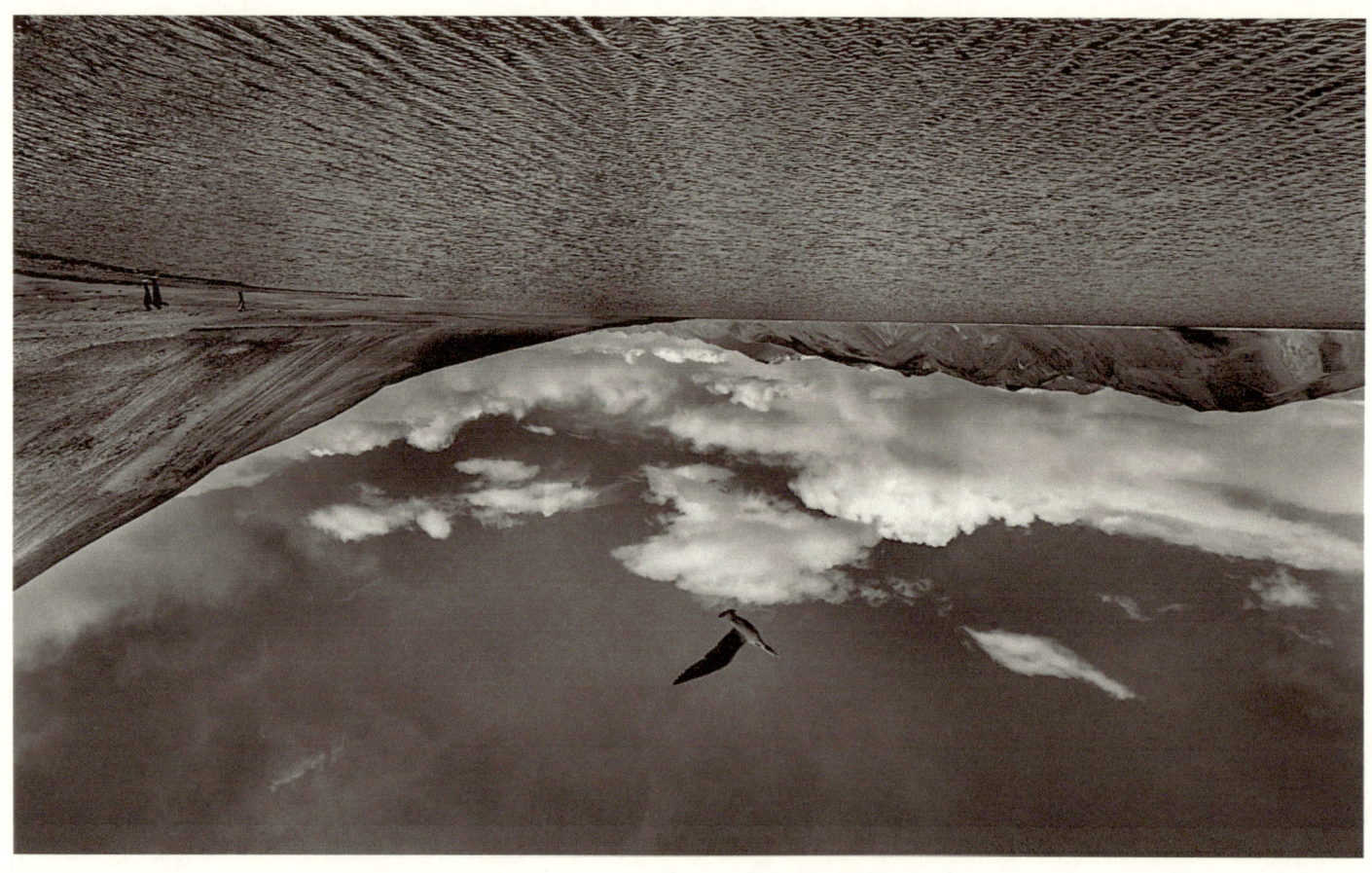

Preface

Perhaps, I was only 12 or 13 years at that time. I still distinctly remember, I used to keep on looking at a six-paged calendar that hung at our study room. It was a black & white calendar, containing twelve images of an unfamiliar land. Those pictures contained sky, clouds, mountains, people, birds and many more other stuff; I used to get lost almost instantly in an unknown terrain, following the path of childhood fantasy and imagination. Closing my eyes, I used to see bits and pieces of this mysterious land which was practically impossible to be accommodated in such a short space of a calendar. I was told, the name of this mystifying land is "Ladakh" - at the extreme North-end of Indian map.

As usual, that calendar was replaced by a new one in the New Year, God only knows if the new one was of flower, bird or anything else! My endeavour will surely go in vain if I try to recollect those now. However, this is not at all important for me to remember it now, not even the black & white calendar… that was lost forever. But, it is imperative that the images of the lost calendar had successfully planted a seed in my developing mind - "Ladakh"

After this episode, wherever I saw any picture of Ladakh, I would get instantly engrossed with it. Wherever I came across any write-up on Ladakh, I started reading vehemently. Many a times, I intruded into any discussion on Ladakh, in most of the cases unwanted. From that time, I fell in love with Ladakh, silently. After a long time, I got the opportunity to see Ladakh by myself… not through the printed words or images but through my own eyes. After I observed this land minutely, the childhood fantasy was replaced by some other things. The first thing that

came to my mind after seeing Ladakh was - "wonder". Ladakh is wonderful by its nature, by history & philosophy, by custom & culture, by religion & human-relation, Ladakh is wonderful by all means! I don't really know if any other place exists in India that is as versatile, as beautiful as Ladakh! In the meantime, I had taken up photography as my biggest passion and discovered Ladakh to be an amazing place for expressing myself through the images I capture. My interest on Ladakh per se from childhood (although through pictures) and Ladakh being a paradise for photographers of my genre -- this happened to be the most advantageous coincidence, if I may say so!

I started capturing images (in 2012), started speaking to the locals and monks, studying about their history-geography-culture-religion in my own way, which actually helped me understand this land in a better perspective. Whatever I learnt and collected these many years, I wanted to share with the larger community; practically in other words, I wanted to share my joy and feeling of happiness. This is precisely how I conceived the idea of creating this book. I have selected only the relevant pictures and added descriptions to portray an image of Ladakh by and large.

I covered more or less the main portions of Ladakh in this book, entering from Srinagar to Leh (the main city of Ladakh) by road via Zoji La Pass, Dras, Kargil, Lamayuru and also described all important and significant places worth visiting alongside this road. I have also incorporated the interesting and the places which are "must see" in and around Leh that includes Nubra Valley and Pangong Lake as well. Consciously, I have entirely excluded the interesting points alongside the Manali-Leh route and Tsomoriri Lake etc. as these images and description demand to be included separately in the second part of this book.

Mainly this book is a collection of photographs, but to portray the land from holistic point of view, the relevant descriptions are added. However, it is important to say that the narratives have never been used to explain the context of the images here - that is to say, the images and the portrayal have not moved forward hand in hand but have actually become complimentary to each other. Hence, the images used and the descriptions given, not to be viewed separately here as they may not carry the content properly of a given subject in its entirety. Therefore, I think, to appreciate the flavour of the land, the images and narration need to be intermingled together before reading.

This book is not a travel-description and therefore, images and narration are not presented in the style of a travelogue. While much of the information is easily accessible today to anyone by scratching the magic lamp called "Google Search", I thought, including information available on "Travel Guides" would add junks on the pile of other junks. On the contrary, I wanted to describe the historic and geographical background, nature, environment, social culture, religion, philosophy to make it a fulfilling experience to my readers and viewers. To give this presentation a total impersonal look and feel, I did not include my personal experiences and emotions, though I found it very difficult to avoid this while writing. However, I shall try to pen down my personal experiences at Ladakh in future, if time and opportunity permits.

In spite of this book not being a travel-companion, I strongly believe the one who already visited Ladakh and who have not, both of them will rediscover and discover Ladakh respectively by reading this book. This belief actually worked as a driving force towards creating this book.

It will not be wise to take self-responsibility of analysing the future success and failure; rather it should be left to the hand of the ones who would be reading this book. But one thing I might proudly proclaim here that there were no dearth of energy and care from my side in creating this book... and I don't want to deprive myself from this tiniest credit. If at least one out of many becomes interested in knowing Ladakh after going through this book, I would consider myself to be the happiest person of the world.

The ones who are interested in photography: The images used in this book are taken by Nikon D7000 and D3000 cameras in the year 2012 and the lenses mainly used are Nikkor 18-105 mm and Tamron 10-24 mm. The images were post processed in Photoshop CS6.

There would be a gross mistake on my part, if I do not acknowledge my gratefulness and gratitude to the numerous elder and younger photographers and writers who have relentlessly kept on inspiring me by their wonderful work all the time. I am also specially grateful to my family and close friends who have tolerated me and my absurd ideas concerning this project and to my utter surprise, advised me on so many stuff to best of their abilities, to take this project forward. Last but not the least; I would like to thank Partridge Publication India for taking the responsibility of publishing this book.

My special gratitude to Shaswata Mukhopadhyay, Bhaskar Sanyal and Suparna Bhattacharya for helping me develop the script and relentlessly putting in their efforts in correcting the manuscripts time and again.

x

Since I have collected the information mainly from Wikipedia and other Government and private relevant websites, I would remain grateful to the respective authorities. Rest of the information was collected from numerous books and magazines(which is lengthy and could not be accommodated here) and while personally visiting the places.

In spite of my best care, there are possibilities of committing some inadvertent mistakes.. Hence, I would be grateful to them who would kindly point out the mistakes to me for betterment in future. I wholeheartedly welcome any kind of criticism, advice and suggestion from my readers. The ones, who have already gone through these lines by spending so much of their valuable time and preparing themselves for turning over to the next page, my heartfelt thanks and gratitude to them! Happy reading!

Best regards,
Deb Lahiri

19A Dharmatala Road,
Kolkata – 700 042
India
e-mail :deb_lahiri@yahoo.com

Kolkata, India
15th August, 2019

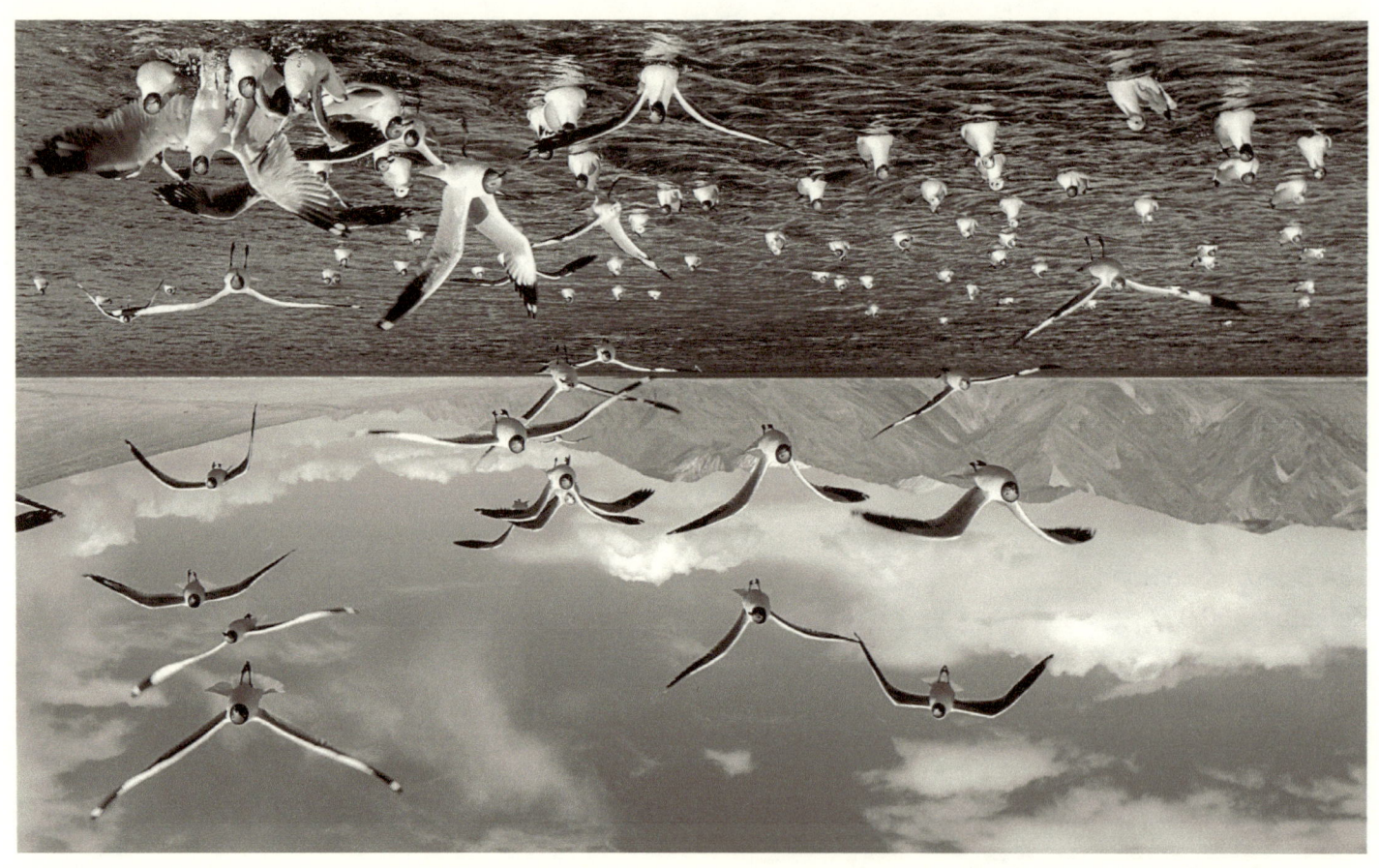

Contents

Chapter 1:	Location & Nature	1
Chapter 2:	Human beings	5
Chapter 3:	Culture	9
Chapter 4:	Mysterious Buddhist Monasteries and the Lamas (Monks)	11
Chapter 5:	The Route	15
Chapter 6:	Influence of Kashmir	17
Chapter 7:	Srinagar-Leh National Highway	21
Chapter 8:	Zoji La	23
Chapter 9:	Dras-Kargil	25
Chapter 10:	Mulbek Monastery	29
Chapter 11:	Fotula	31
Chapter 12:	Lamayuru	33
Chapter 13:	Land of Broken Moon	35
Chapter 14:	Khalse-Saspole	37
Chapter 15:	Alchi Monastery	39
Chapter 16:	The confluence of Indus- Zanskar	41
Chapter 17:	Leh Town and its people	43
Chapter 18:	Hemis Monastery	47
Chapter 19:	Thiksey Monastery	49
Chapter 20:	Shey Palace	51
Chapter 21:	In and around Leh	55
Chapter 22:	Khardungla	57
Chapter 23:	Nubra Valley	61
Chapter 24:	Diskit Monastery	65
Chapter 25:	Cold desert	67
Chapter 26:	Samstanling Monastery	69
Chapter 27:	Changla	71
Chapter 28:	Pangong Lake	73
Chapter 29:	The last words	75

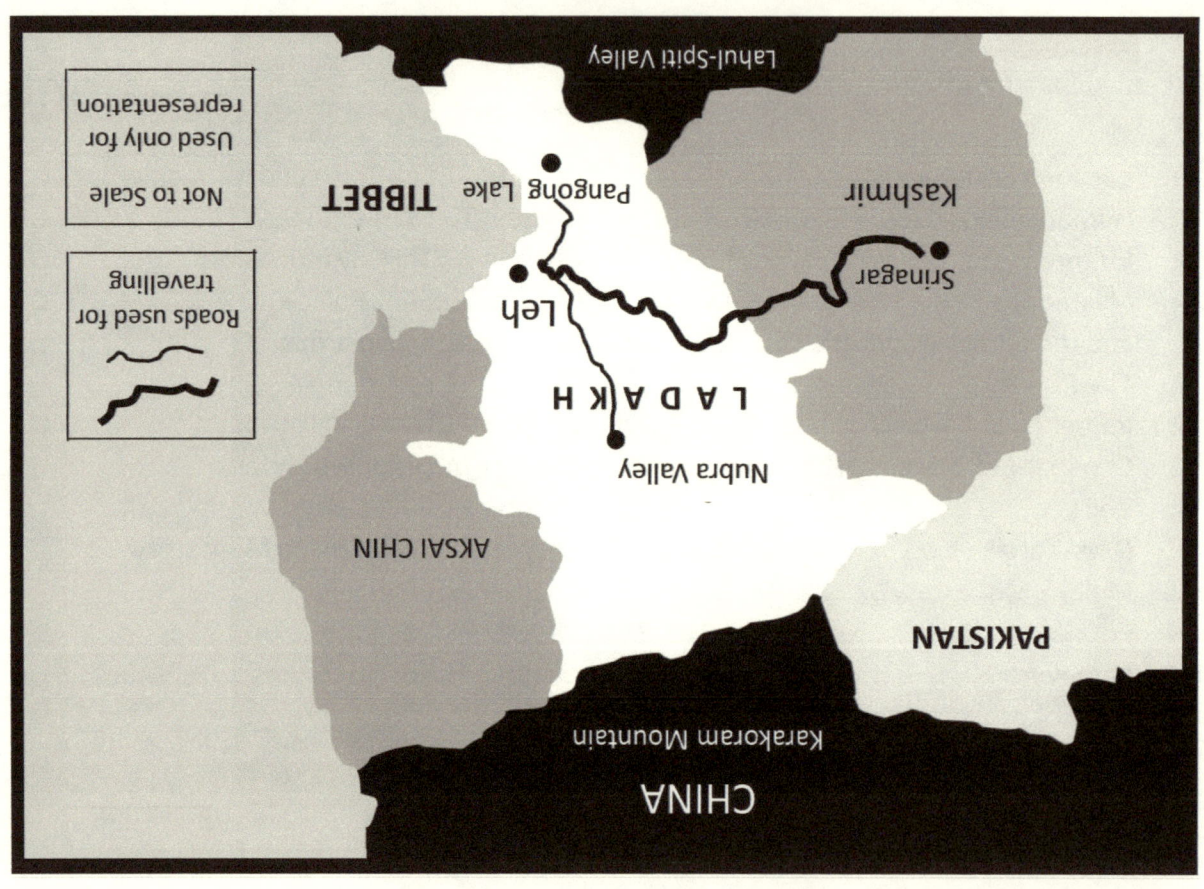

Chapter 1: Location & Nature

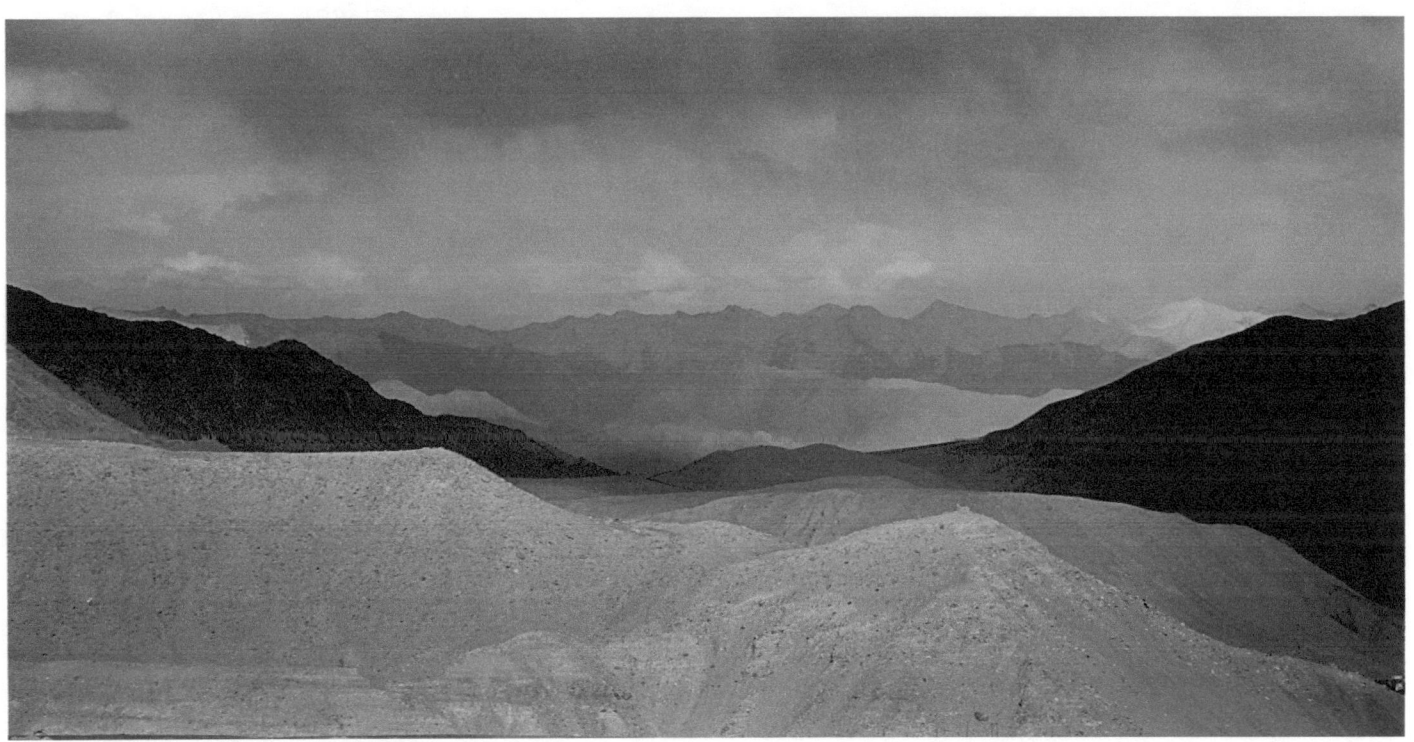

Almighty shines at the pinnacle of universe; likewise Ladakh has precisely secured the topmost position on the Indian Map, touching the peripheries of three foreign countries. Out of these neighbours, Tibet situated at the eastern part of Ladakh. The border of political China, spreading from the northern side of Ladakh has touched Tibet towards the East. In the West, it is Baltistan, a part of Pakistan-ruled Kashmir. In the North and South, Ladakh is covered by two wrappers made of two most famous and large mountain ranges — the Himalayas and the Karakoram. Karakoram spreads towards the North and in South, the great Himalaya stretches its arm from far-away Bhutan, as if hugging Ladakh with warmth of affection. The diversified beauty of Ladakh is inexplicable. Dazzling snow-capped mountain ranges in one hand and on the other hand there remain spectacular abstract sculptures on the bare mountain surface. You would find the cold desert in seclusion with silver sand dunes while lush greeneries are also waiting for you at some other parts of the land.

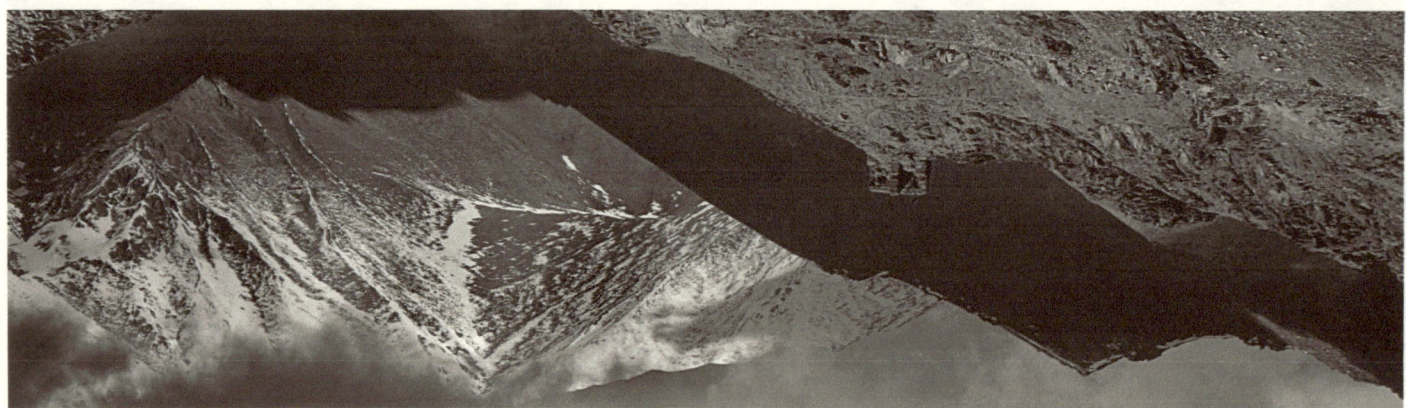

Blue sky and white clouds are Ladakh's monopolistic ownership; nobody dares to take a share of its possession. Amidst the tree-less deserted terrain, there have been mountain ranges with a thousand shades of black and brown, mingled with more superior orange, violet, dark blue, blackish green and even with pink mountains peaks! Just riot of colours. One would surely feel that an engrossed artist is in the course of experimenting with vibrant colours and brushes on the vast canvas of nature. Dark blue sky and white clouds have become the frame of this canvas.

'La' means mountain pass, 'Dakh' denotes country... in other words, Ladakh is a country of mountain passes. Ladakh does not have any significant peaks in its possession, nevertheless, it is covered by numerous mountain passes. One of these passes Khardungla (18380 Ft) has snatched the crown of highest motorable pass of the world.

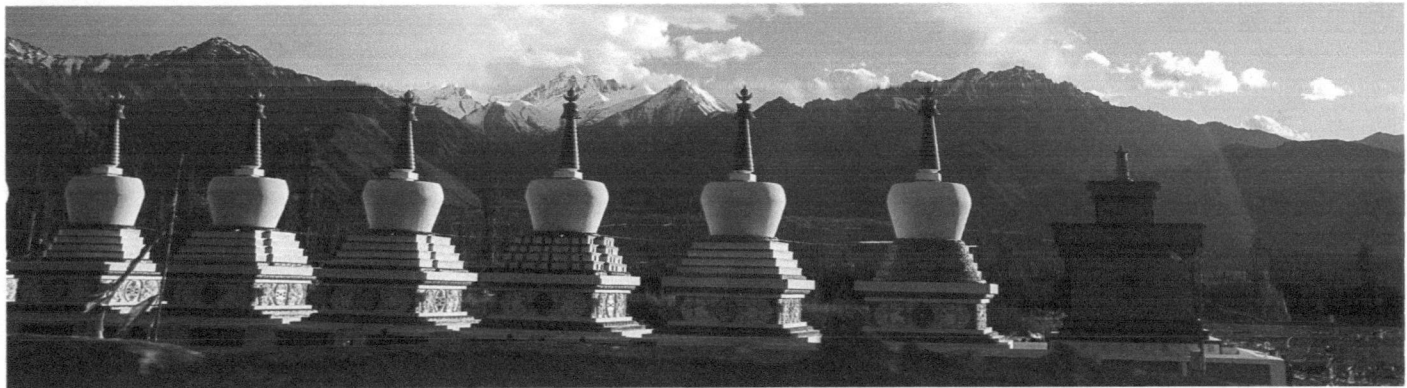

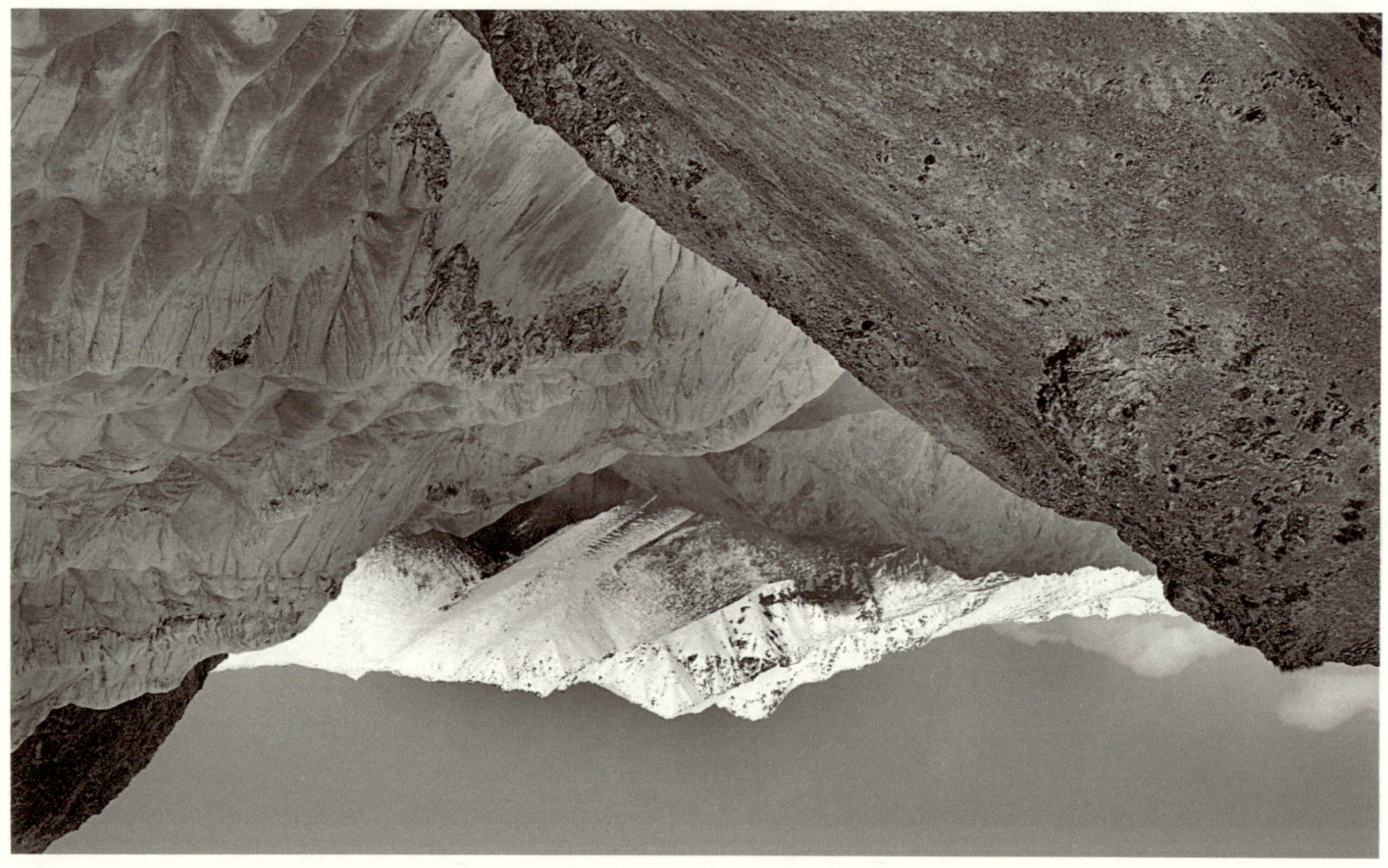

Chapter 2: Human beings

Ladakhis believe in superstitions and ghosts. It is said that in the ancient ages, entire Ladakh was under deep water. The legend goes that approximately in 1100 BC, Pundit *Mahashuddhacharya* Naropa from Kashmir made this inaccessible land habitable after his long religious austerity. By virtue of his prayer, it was said, the water level came down gradually and the mountain ranges started raising their heads. This land subsequently became the grooming field of two tribal groups - Dard and Tibetans. In 2014, population of Ladakh was just more than 2.5 lakhs, out of which many old tribal groups are seen.

Undoubtedly, Ladakh is a significantly vast region but it has only two Indian Districts - Leh and Kargil. (On August 2019, the Parliament of India passed an act by which Ladakh will become a union territory on 31 October 2019). Leh is a Buddhist infested land while in Kargil, Muslims of Shia community are majorly seen. There live a few Christian families as well. The Christianity came to Ladakh along with the Moravian Missionaries. The people of Ladakh mainly speak Ladakhi - this language was actually originated from Tibet.

The people of Ladakh are very hard working like any other individuals of hilly areas. They are very simple in nature, the vices of modern age do not have any impact on the minds of these round faced, flattened nose innocent people. It goes without saying that these smiling faced people have more similarities with Tibetans rather than Indians or the other races of Middle East.

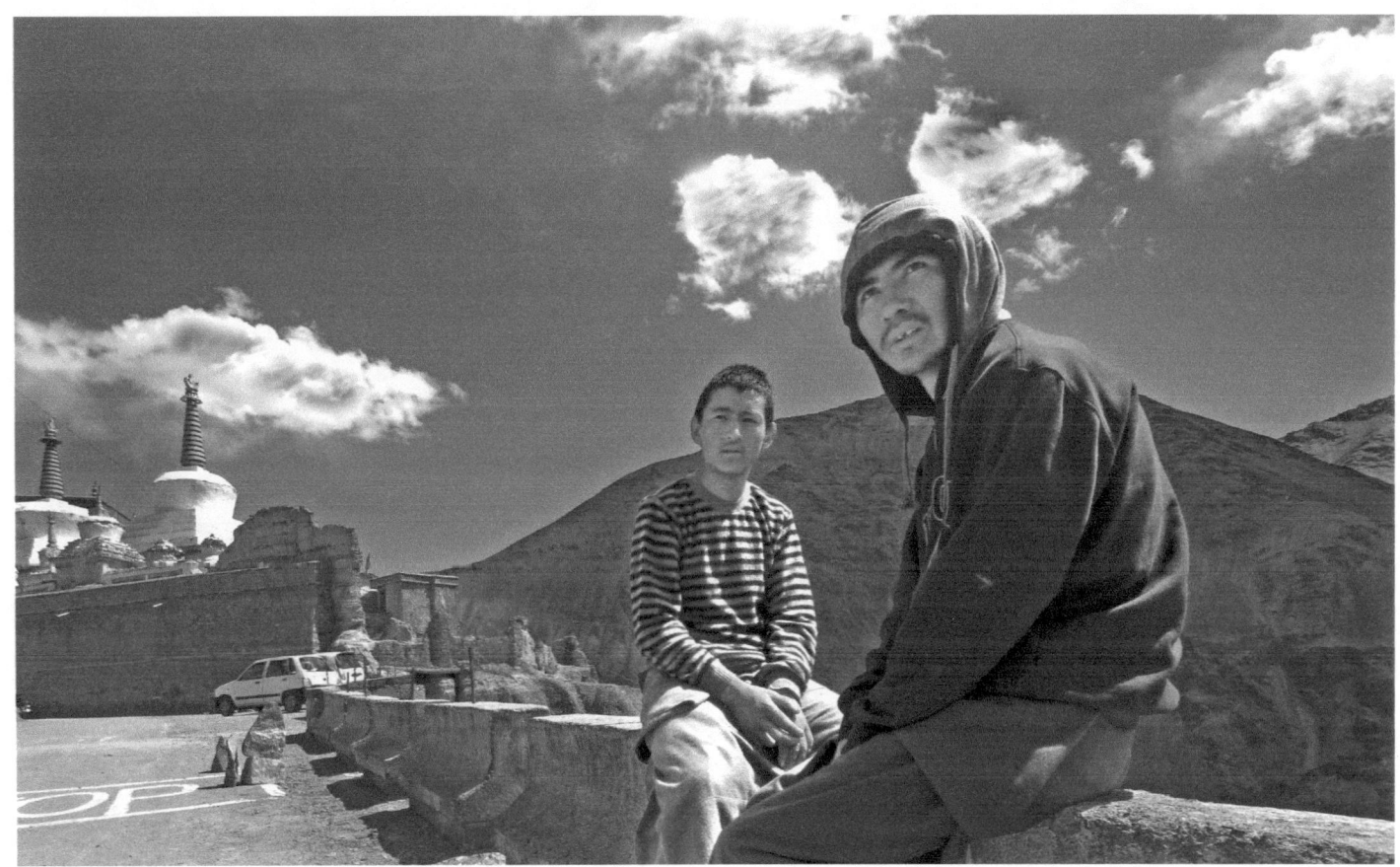

Chapter 3: Culture

History says, once upon a time Ladakh was the capital of Tibet. This capital was established by the last emperor of Tibet- Langadharma. In the first century, Ladakh was included in the empire of Khushuna. Baltistan and Aksai Chin were also included in Ladakh. The then Baltistan is now under Pakistan and Aksai Chin is a part of China today.

Ladakh, being the crown-holder of diverse commercial activities throughout many centuries, had adopted the culture of various countries of the Middle East. Out of those nations, undoubtedly Tibet had influenced Ladakh to a great extent. The Tibetan culture got mixed with various local rituals, customs of other countries. Buddhism came to Ladakh from Kashmir; Kashmir was a Buddhist majority region at that point in time. As a matter of fact, Buddhism was spread to Tibet in the second century from Kashmir via Ladakh. Right from this era, Ladakh was considered to be one of the most important centres to cultivate Buddhism. When the adjacent places of Ladakh like Kargil, Baltistan, Afghanistan etc. were gradually turning towards the Islamic religion, only Tibet remained as the most faithful friend of Ladakh, in terms of exchange of Buddhist culture. Today also the influence of Tibetan culture is predominantly evident in the civil societal structures - be it a dwelling house or Buddhist Monastery. One would also find resonance of Tibetan tunes in Ladakhi music, even in chanting of musical Mantras by the Lamas (Buddhist monks). That is the reason why Ladakhis take pride in calling Ladakh as "Little Tibet". Racism does not exist among the Ladakhis, exactly like the Tibetans. You will not find upper caste - lower caste discrimination in Tibetan social culture. The females in Ladakh also enjoy the same social status as males which is extremely unusual in other parts of India, especially in under developed regions.

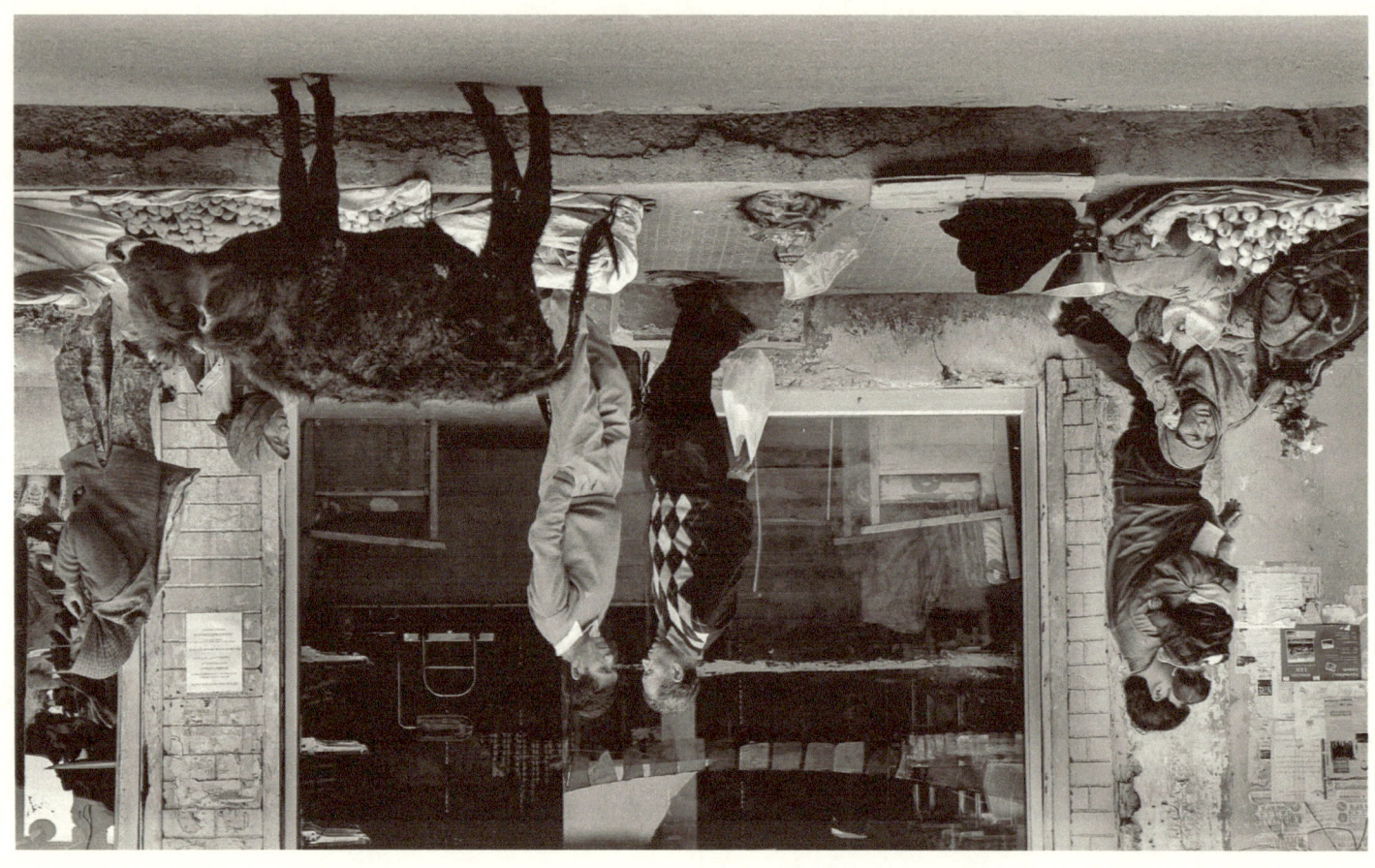

Chapter 4: Mysterious Buddhist Monasteries and the Lamas (Monks)

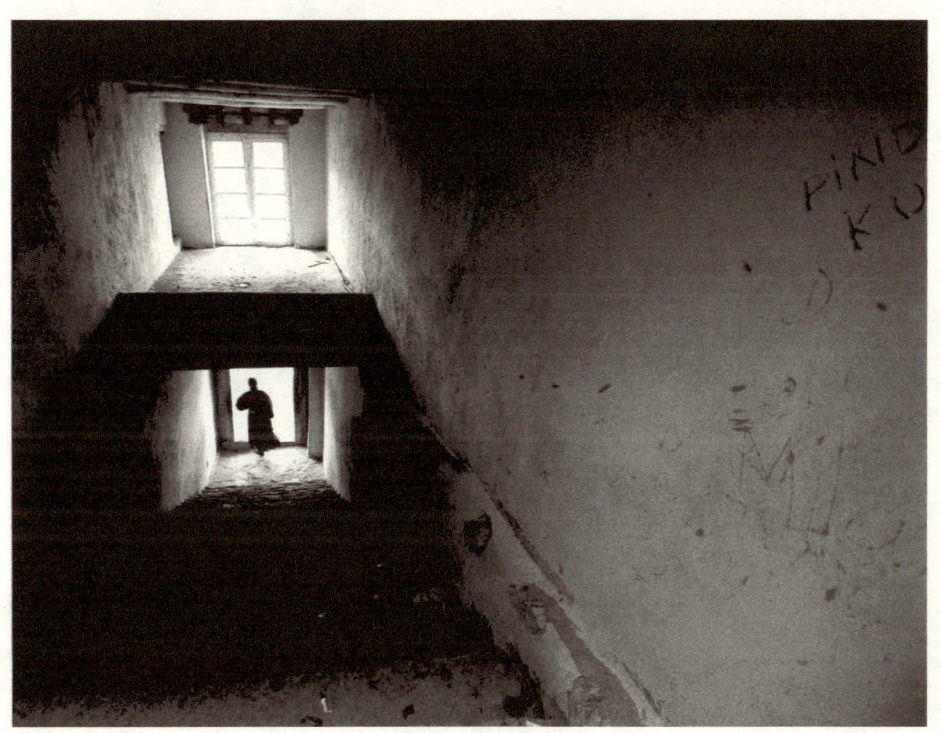

The Buddhist Monasteries of Ladakh is predominantly different in shape-size-culture-custom from the other Buddhist study centres of the world. Mostly these monasteries are isolated from the world on the top of the hill in a beautiful serene place amidst Mother Nature. One has to climb up the hill a little to get into these monasteries, made of bricks, stones and woods. The main house for prayer and the resting place for the Lamas - mostly the monasteries are constructed along these lines. The inner apartments of the monasteries are in some way mystery-clad.

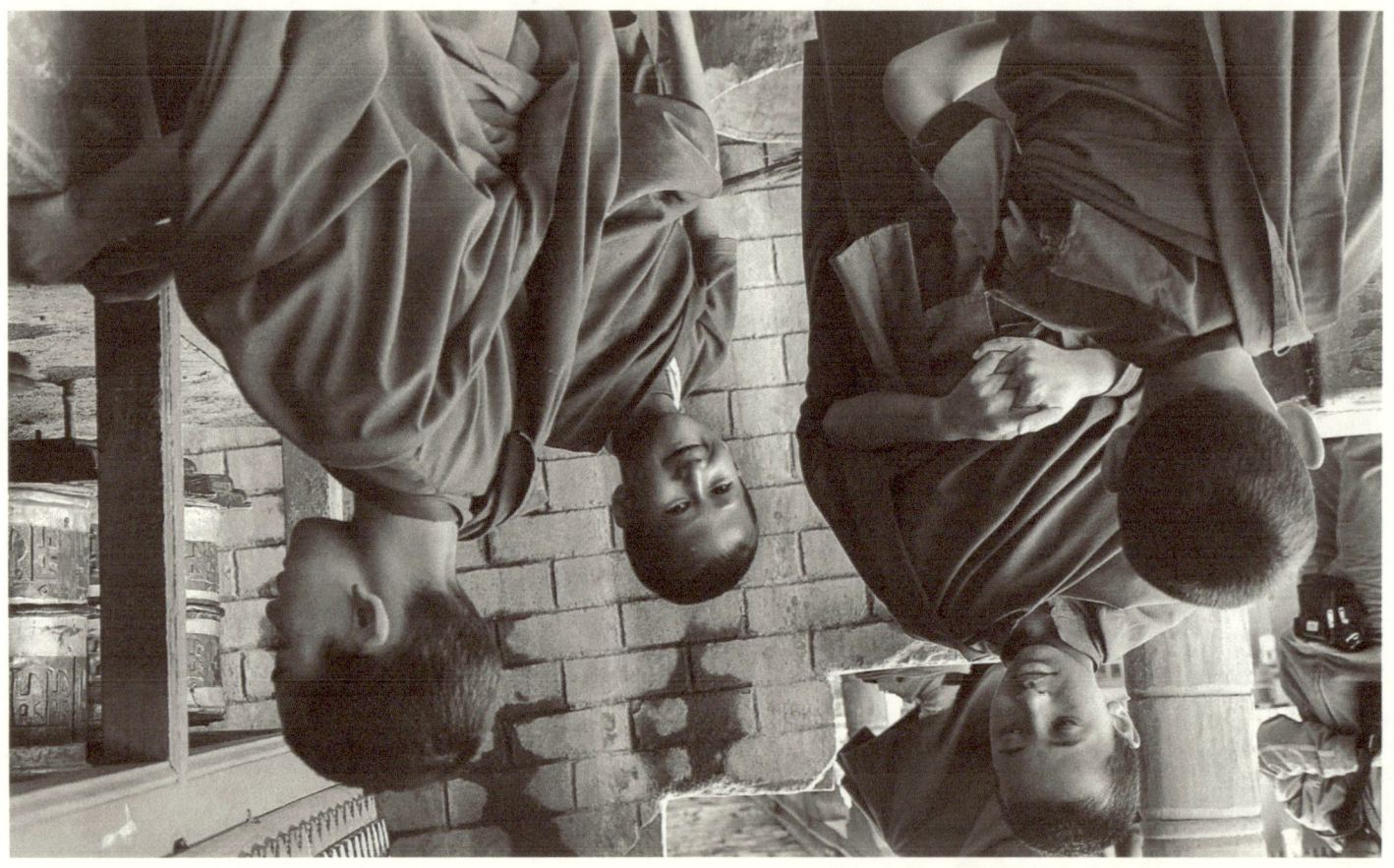

The main entrances of the monasteries are generally low in height so that one has to bend his head before the almighty while entering.

Once you enter the premises you are struck with the mysterious environment in the semi darkness. Nothing is apparently visible as it should be. On top of this, there has been a strong smell of resin, paraffin or something of that sort. Once your eyes get accustomed with the thin ray of light trespassing from the skylight, you would see all the walls are covered by the strange and vibrant images of god and goddess. Most of these images are made of mural. In the closet made of semi-transparent glasses, there exist candle-dolls, crafted by Lamas, utensils, bells, old and faded manuscripts worn to shreds.

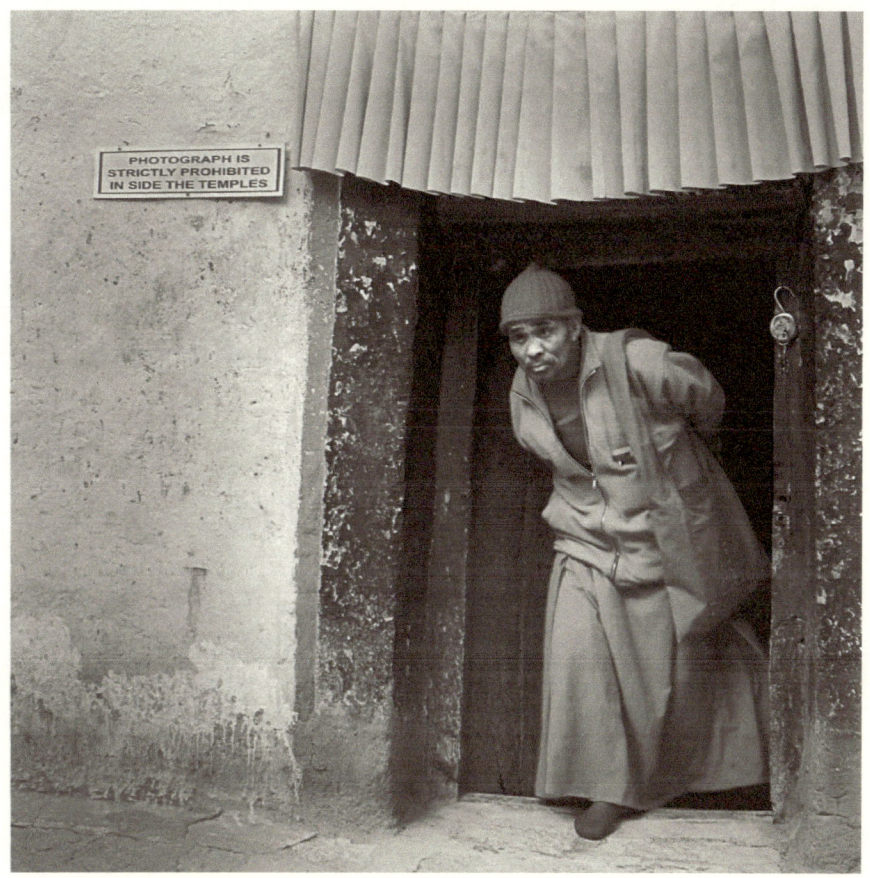

In the front, on a tall platform Gyani Buddha (Maitraya) conspicuously exists. In Ladakhi language the "Maitrayea" image of Lord Buddha is called Chamba. Most of the times, chanting of mantras by the Lamas or the beats of deep-toned musical instruments are heard from the interior apartments of the monasteries. Interior apartments are called Dokhang. These are basically prayer halls of a monastery. Generally, in all the monasteries there exist another room adjacent to Dokhang - In this room they usually keep the idols of death's god and strange masks that will surely make one terrified. At the time of mask-festival, the Lamas wear these staff while performing mask-dance. Outside there are Chortens in rows (temple shaped constructions made of bricks) and series of prayer wheels. Lamas of all ages with their simple and innocent faces, always roam around in various corners of the monasteries.

Chapter 5: The Route

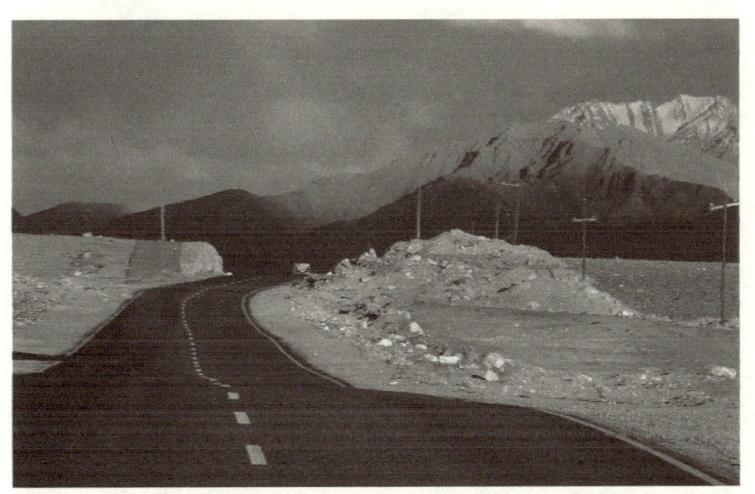

Ladakh is connected with the rest of India mainly in three ways. The Leh-Manali National Highway is connected to Leh (11556 Feet), the capital of Ladakh at the bank of Indus river from Manali (485 Kilometres) of Himachal Pradesh via Rothang-Kelong-Sarchu-Lachungla-Tanglangla. The glorious beauty of the picturesque nature alongside this road is stunning. On the other hand, Leh-Srinagar highway (National Highway Number one) has touched Leh via Sonmarg-Zoji La-Drass-Kargil-Lamayuru(434 Kilometres). Beauty of landscape mingled with numerous historical events have made this road significant to the tourists and researchers. Third and the last rout is by Air - directly flying to Leh from Delhi, Srinagar or Chandigarh. By air travel, one is going to miss the magnificent beauty of the landscape certainly, nevertheless, the breathtaking sight, right from top of the Himalayan sky, will be an additional dividend. Absolutely a stunning view! The extreme point, till your vision travels, you would see a spectacular scene of snow-capped barren mountains in the backdrop of the blue sky and an ocean of white clouds.

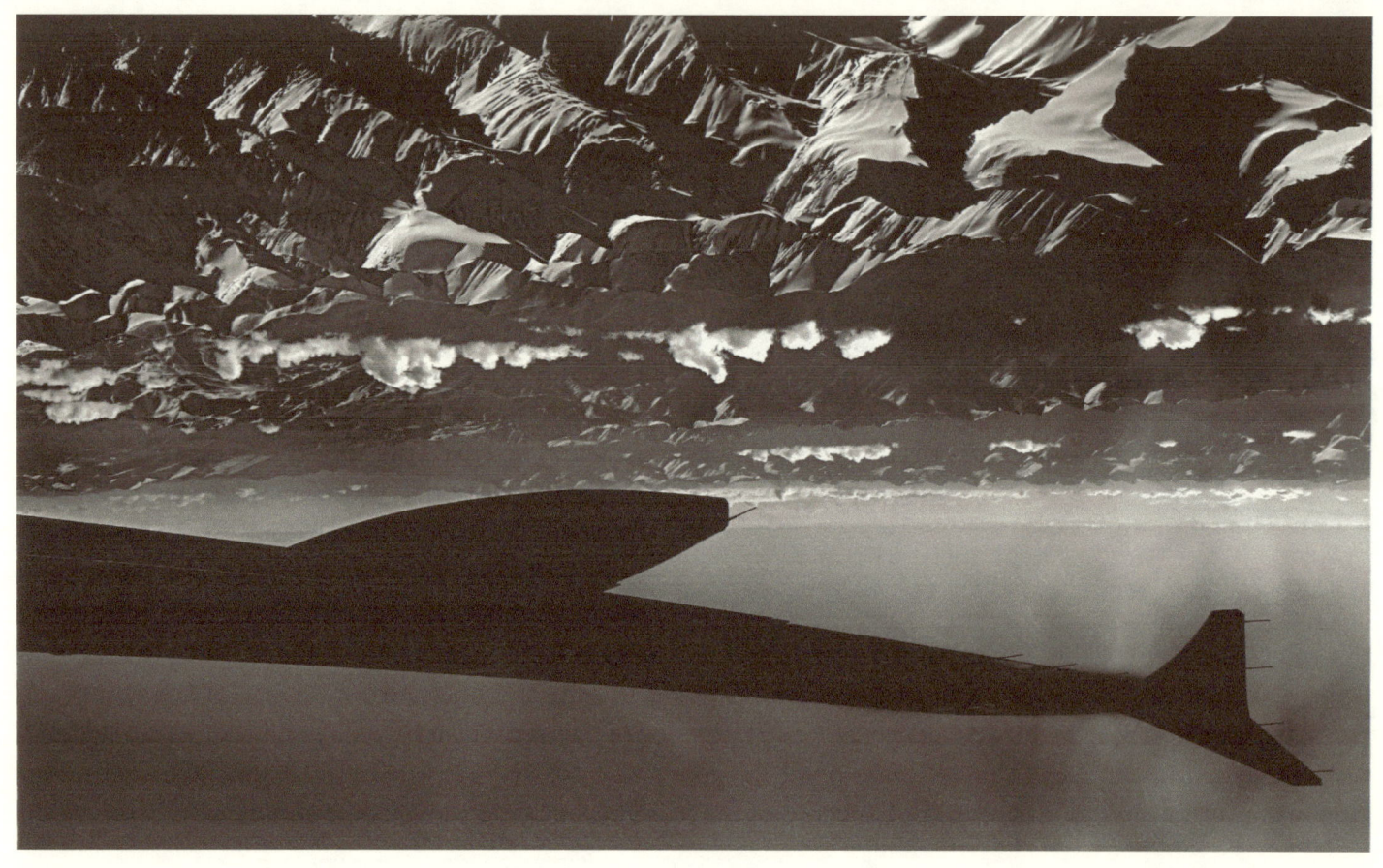

Chapter 6: Influence of Kashmir

Since early days, Kashmir was the only connecting point of Ladakh with India and rest of the world. Also the road coming from Himachal Pradesh to Ladakh is not very old. Before this, the road from Kashmir to Ladakh via Zoji La Pass was the only link for communication with Ladakh, China and Tibet from India. Politically, till 1979 Ladakh was merely a district of Jammu and Kashmir state of India. Subsequently, central and state governments of India decided to divide Ladakh into two districts - - Kargil and Leh and transferred the administrative control to an autonomous hill council followed by strong agitation by the locals. In 1993 both the districts got the honour of two autonomous administrations under separate hill councils.

These councils jointly with the Village Panchayat look after the economical development, public health, education, agriculture, distribution of land and other local activities. Law & order, Judiciary system, Communication and Higher education are the areas where Jammu and Kashmir state government plays the role.

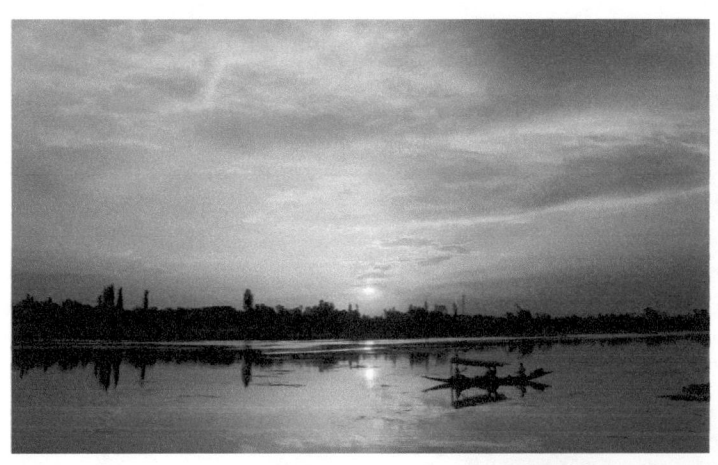
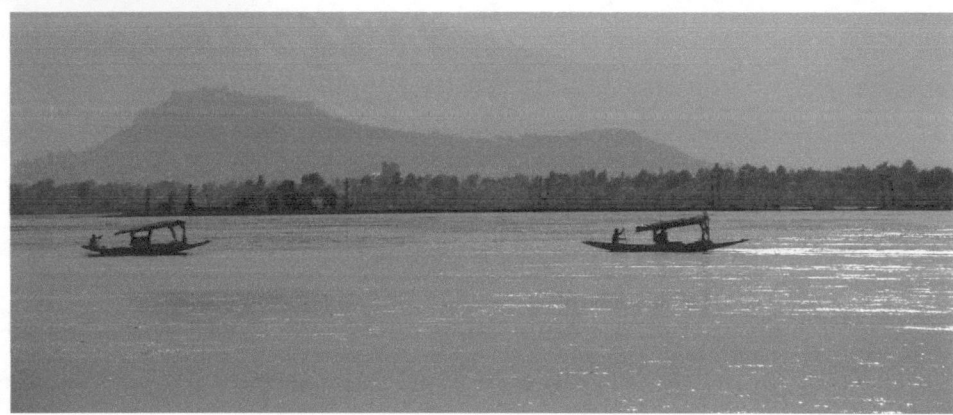

Chapter 7: Srinagar-Leh National Highway

The Srinagar-Leh National highway, to simply put, is an assortment of scenic beauty, history and thrill. This road was honoured as a National highway in the year 2006. Border Roads Organisations (BRO), like the other hilly borders in India, takes care of this highway. Though the honour of "National Highway" came late, nevertheless, this road has secured its permanent position in old history chapters. If you scroll through the yellowish and discoloured pages of history, you will see this road, alongside the Indus river is flooded with commercial commodities in the seventeenth and eighteenth centuries. The busy road transports various commodities on carriages by the animal carriers like horses, camels, asses etc. As far as establishment of business relationship is concerned (with various countries in Middle East Asia), the importance of this road was unfathomable. Good quality of raw silk used to be imported from Tibet for the world famous silk industry of Kashmir. If you dig further into the past during the reign of emperor Kanishka, this rout was used for the grand convocation of Buddhism at Kunal Ban of Kashmir.

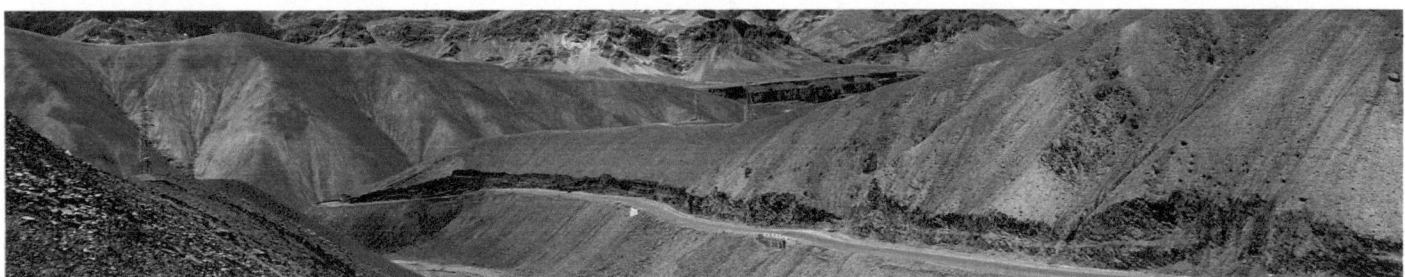

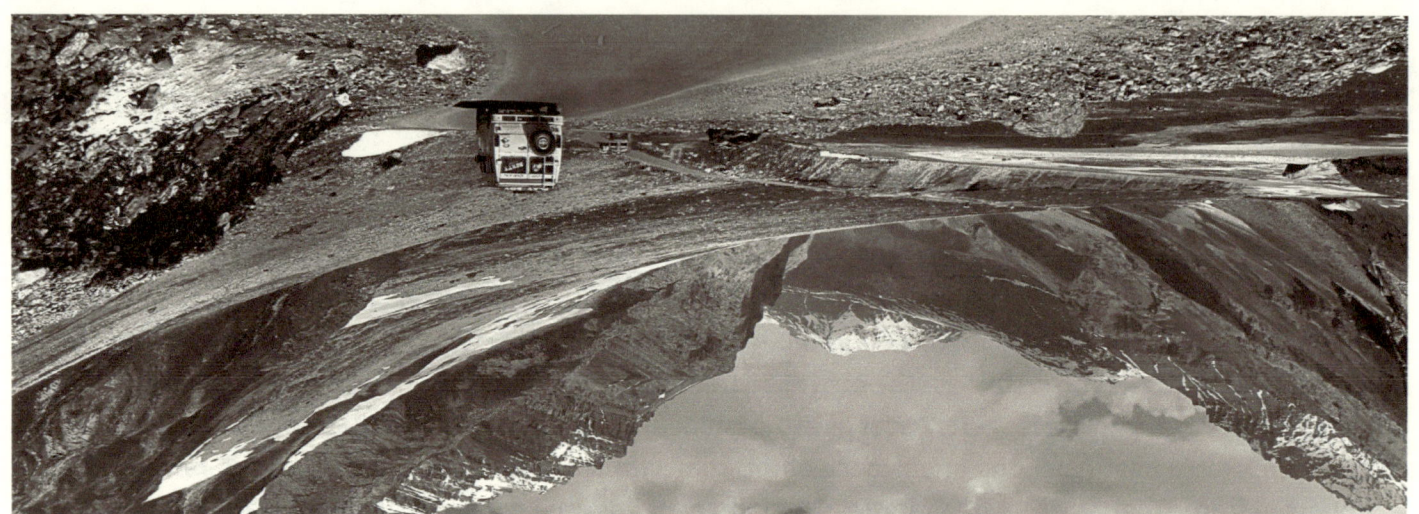

The prince of Tibet, Rinchen used this route to capture Kashmir in the year 1319. The Mughals also chose this route for launching attacks on Kashmir. Swen Andris Hedin, an adventurist-photographer-travelogue writer from Sweden discovered Turkisthan of China and Tibet through this route during his three daring consecutive expeditions from 1894 to 1908. If one takes the time back to one sunny morning in 1922, he would see a fearless saint with saffron robes is moving forward in bold steps on this dangerous and inaccessible road – He was Swami Abhedananda. With the blessings of Sri Sri Ramakrishna Paramhansa, a well-known prophet from Bengal, the courageous saint crosses this risky, precarious and freezing road in just fifteen days! His unbelievable experiences of travelling on this unsafe and treacherous road are written in his travelogue of Tibet and Kashmir travelling.

Chapter 8: Zoji La

In the Srenagar--Leh National Highway, there are two high mountain passes - Fotula(13478 feet) and Zoji La (11575 feet). Though Fotula is considerably higher than Zoji La, yet Zoji La has snatched the cap of "one of the most dangerous mountain passes" in the world owing to its position and climate. Travelling nine Kilometres from Sonamarg through steep upward way, the spiral road approaches towards Zoji La, leaving on the right hand side, the way

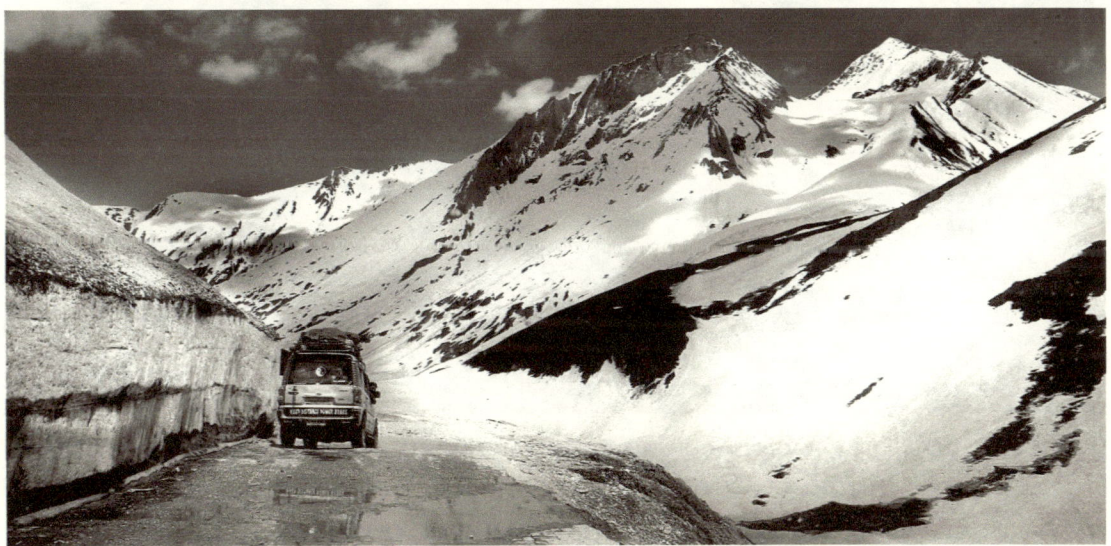

towards famous Amarnath cave via Baltal. If you look around you will find only white snow and snow-clad mountains. On the right hand side there is a gorge made of snow while the wall on the left hand side is made of white ice. The drops of waters rolling from the snow

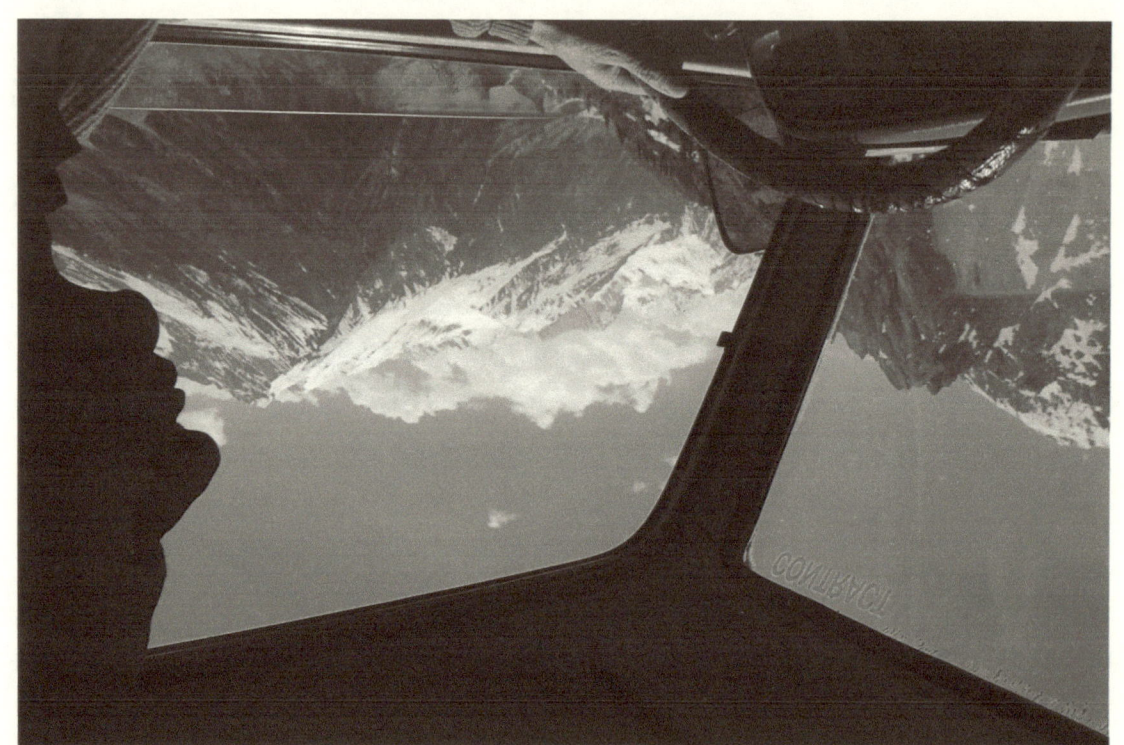

wall suddenly got frozen into ice thus giving rise to Stalactites and Stalagmites. This can be experienced only in summer or autumn. In winter, the entire slippery road goes under the thick pad of ice. During this time, the entire control of the road goes under the strict vigilance of the Army and BRO. Political battle is a steady companion to Kashmir. In line with this phenomenon, Pakistan captured Zoji La 1947. India again regained its ownership through a blood-stained fight in the year 1948 called "Operation Bison."

Chapter 9: Dras-Kargil

Once the Zoji La Pass ends, Dras valley starts, Dras is termed as the gateway of Ladakh. The distance of Sonamarg to Dras via Zoji La is 63 kilometres. In Dras, you have to cross a village called Minamarg. In this region there are many beautiful trekking routes in the Suru Valley; adjacent to Dras. For many centuries, people of Dras have refused to bow down their heads to the snap of biting cold. In the winter, very often the temperature goes down to the level of 20-22 degree centigrade. In such extreme situation, mercury level even touches minus forty degree centigrade at times.

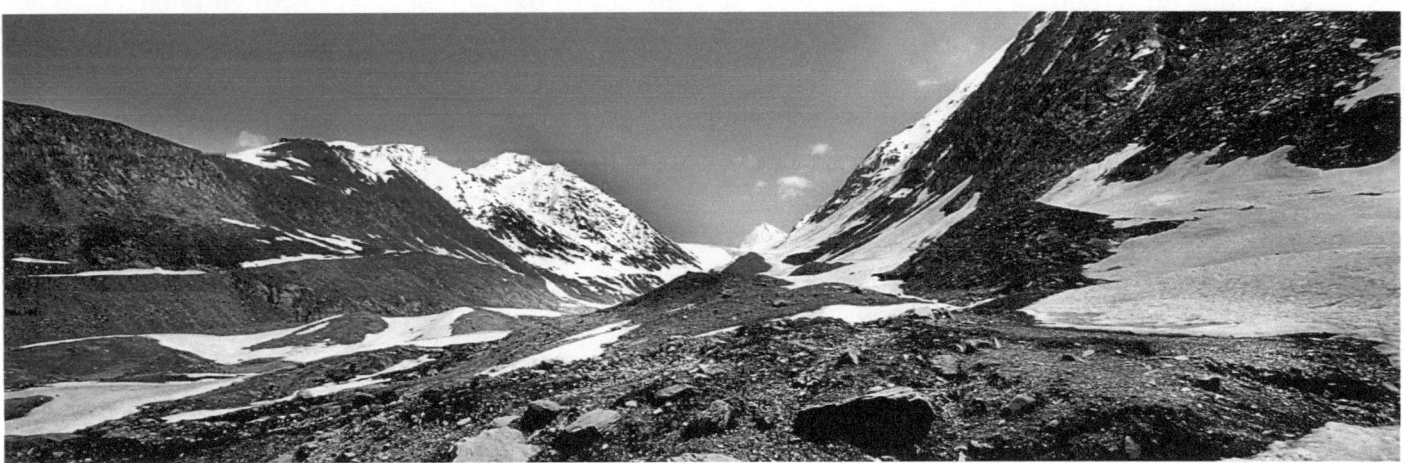

It is known to many that Dras (1099 feet), is the second coldest habitat in the world as of now. This beautiful serene village in the Himalayas' lap suddenly became a part of the world-news headlines in 1999 during Kargil war. This area is located nearer to the border of Pakistan. At the time of battle, the pieces of shells thrown by the Pakistani army had shaken this tranquil environment time and again. The beauty of Tiger hill is noticeable from every nook and corner of the Dras village. Pakistani army captured the Tiger Hill which India had subsequently recovered after 11 days of blood-stained battle at a stretch being codenamed as "Operation Vijay".

In a political battle, one surely takes the pride of emerging victorious at the end of the day but in the course of capturing and then recovering a mere piece of land, many young lives from both the camps are sacrificed.

Dras is an old locality, and the tribe called Dard lives here mainly along with some other races originating from the Aryan community, came from Ladakh to stay at Dras. Possibly these people came from Middle East Asia many centuries ago. The people of Dras-Kargil are very fond of sports. They like to play a game riding on horses, without even considering the international rules which has much similarity with the modern game of Polo. The people of this region do not speak Ladakhi language like any other places of Ladakh; they communicate in a language called 'Shina'.

Kargil (8860 Feet) is situated sixty kilometres away from Dras towards the East of Srinagar-Leh National Highway. The scenic beauties of some places on this way are magnificent. Located on the banks of Suru river, Kargil is also surrounded by various small mountains and peaks, much like Dras. 1947, 1957, 1961!!! No matter who the enemy was, be it Pakistan or China, the name of Kargil came up in the headlines time and again. Fortunately, these political

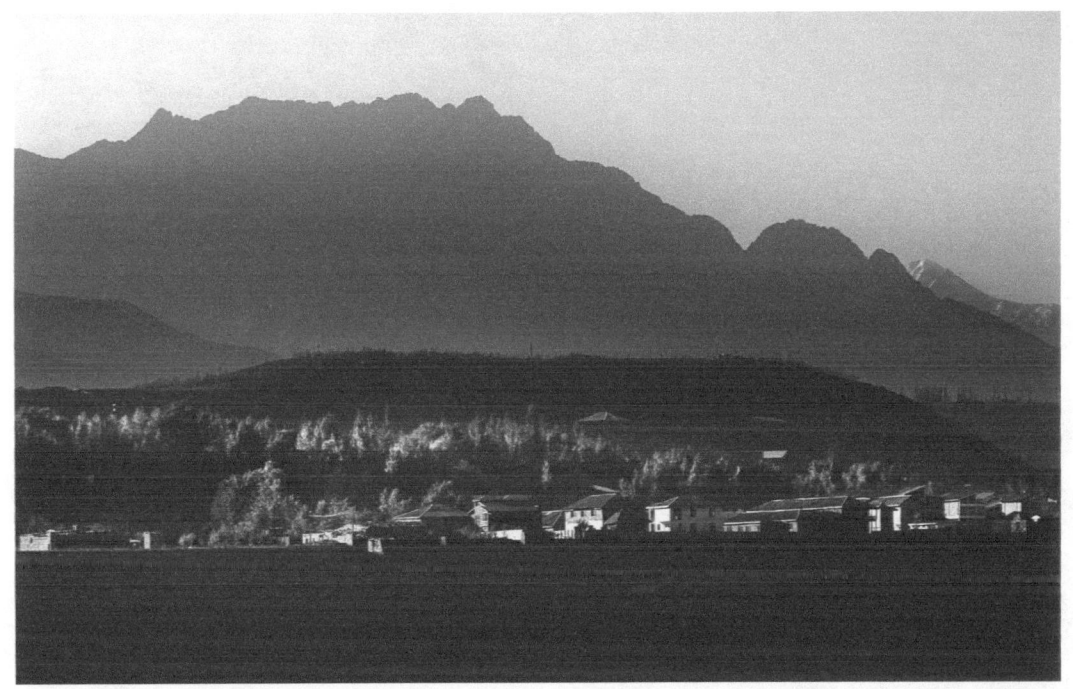

battles did not leave any lasting impression on the faces of the local residents. They are always smiling! It is great to observe the activities of these people in the markets of Kargil. In a four road junction, named Lal Chowk, the trading starts in the afternoon. Being a significant commercial location following the old business-path, tradition of Kargil still stands high. Various commodities like garments, foods, grains, fruits, mainly apricot are sold like hot-cakes. Males and Females, both are buyers and sellers. This place is mainly dominated by the Shia Muslims. If you look at their dresses, colourful caps and the fashionable bearded facial appearances in the semi-darkness of the market place, you will feel as if Kargil; a town of Middle East of many centuries ago, has appeared in front of your eyes with divine influences.

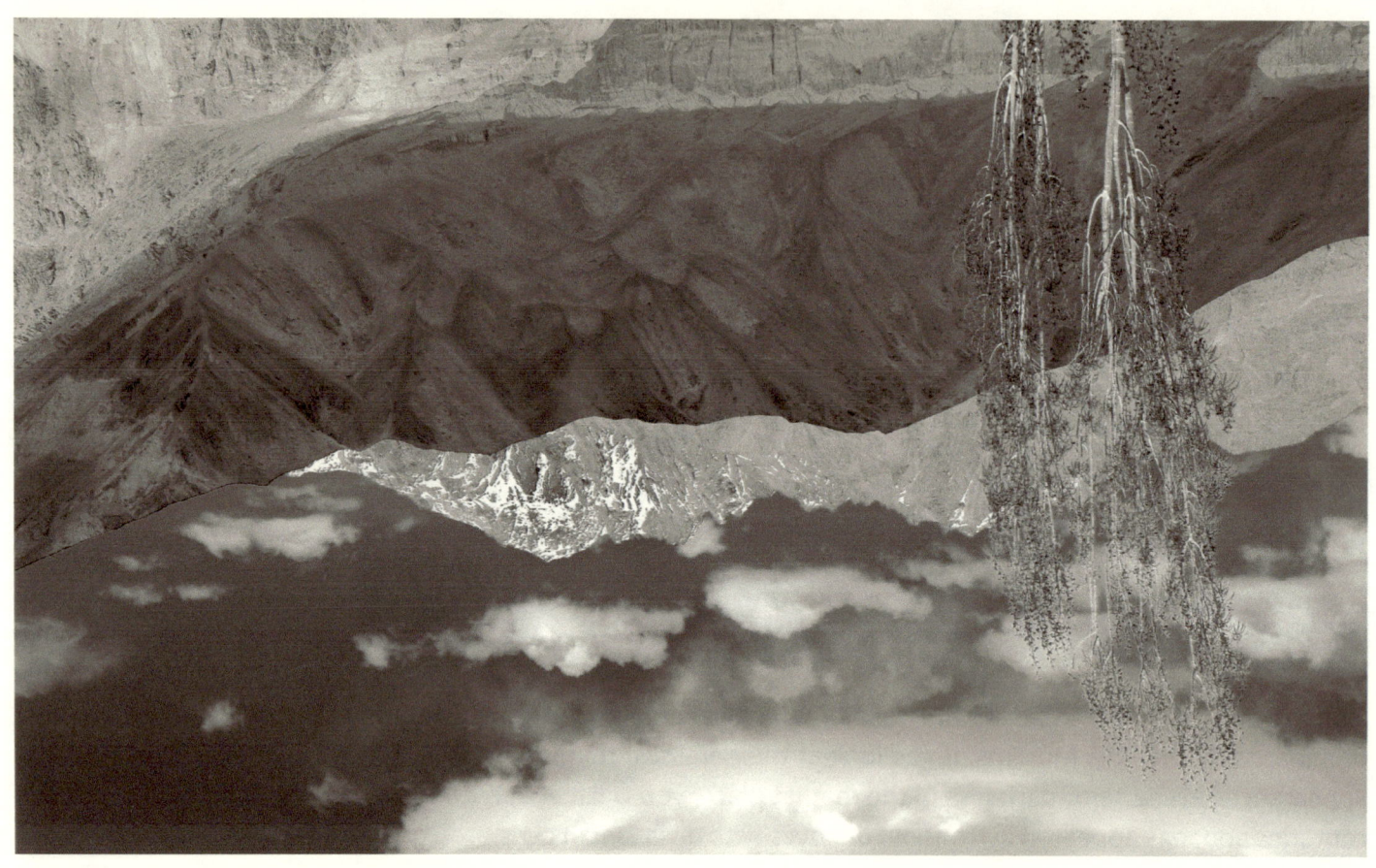

Chapter 10: Mulbek Monastery

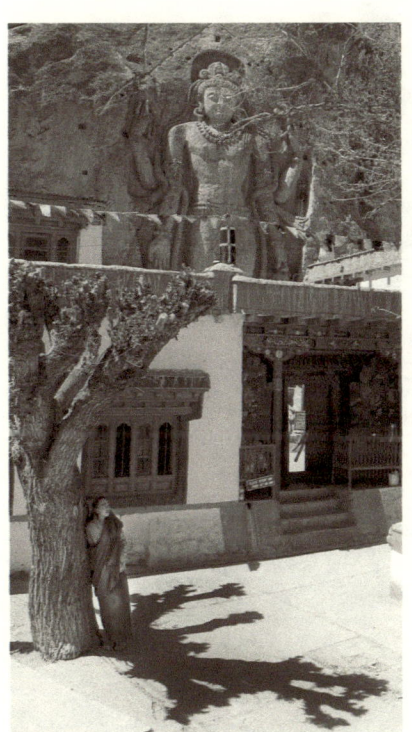

Once you proceed towards Leh through National Highway No.1 from Kargil, the unbelievable nature of Ladakh starts unfolding its petals slowly. 45 kilometres towards East from Kargil you would find a locality called Mulbek. It is neither a village nor a town. One Kilometre away from this place there exist a century old Buddhist monastery. The Monastery is situated at the left side of the road but the main attraction is on the right hand side. You will find a thirty feet Buddha Maitraya statue having four arms, craved on stone. The Maitreya Buddha denotes the pre-asceticism stage of Lord Buddha's life. The rectilinear Buddha looks at the sky, over the top of the age-old path. Denying the traditional culture and depriving the appreciative eyes of art-enthusiasts, Buddha statue's lower portion was covered by a temple in the year 1975. Some of the historians think that this statue was erected at Kushan age, but most of the historians have put the stamp of their endorsements on the fact that this was constructed only in eighteenth century.

Chapter 11: Fotula

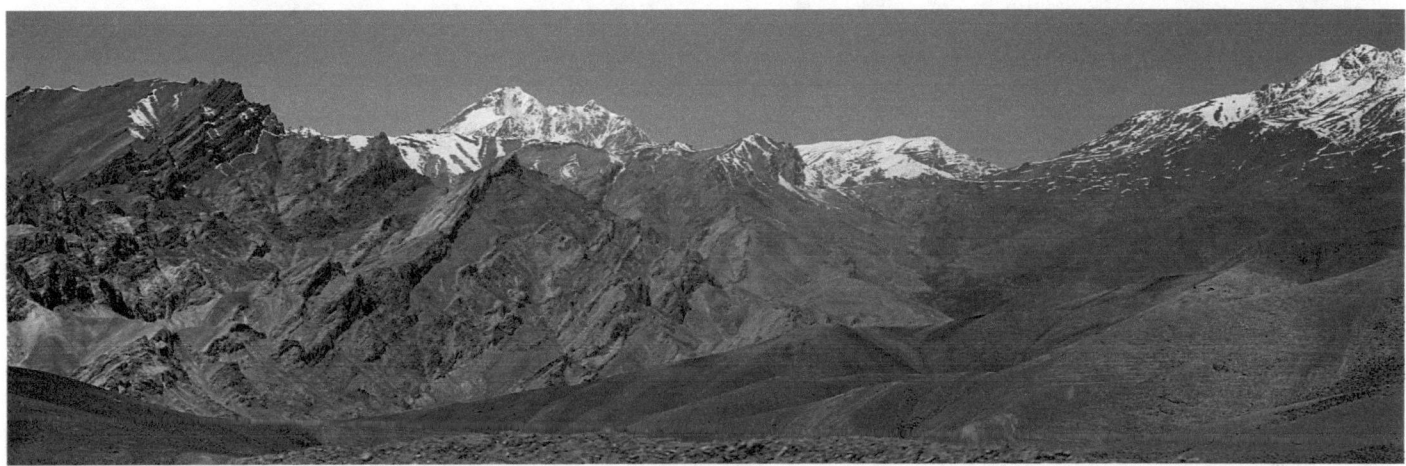

Fotula (13478 feet) has surpassed much-heard and talked about Zoji La pass in terms of its height. Although it is the highest point in Srinagar-Leh highway, yet Fotula was deprived of the honour with such respect possibly for not being such dangerous and fearful. Nevertheless, the highest point on Fotula is an ideal place to enjoy the scenic beauty of Ladakh. The wind rules here throughout the year. Faintly visible Lamayuru and the image of the world famous "land of broken moon" are visible in the backdrop of sky. The sky, as if converted into a huge calendar of nature, creates a magnificent visual impact there.

Chapter 12: Lamayuru

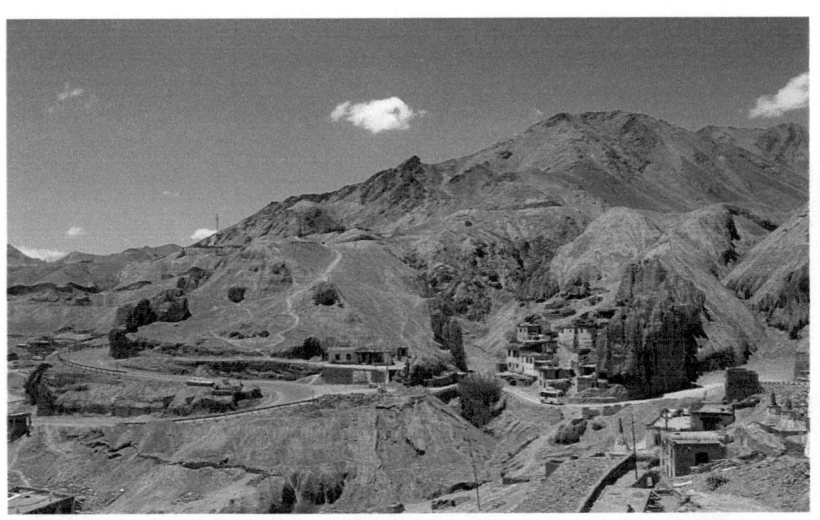

Lamayuru Monastery has secured its place in the map of Buddhist religious activities in Ladakh. It is difficult to imagine as to how this monastery was built almost one thousand years ago at a height of 13000 feet despite such inaccessibility at that point in time. This monastery is the oldest and also the largest in Ladakh. It is one of the major attraction points on the Srinagar- Leh National Highway. Perhaps, in the year 1000, famous Tibetan Lama-Architect-translator Rinchen Jinghpo built 108 Buddhist monasteries in Ladakh and Spiti regions. Amongst these monasteries, Alchi and Lamayuru are the most famous, while other monasteries like Ayangla, Mangu, Sumoda etc. are inaccessible due to their adverse locations Rinchen Zangpo built around five monasteries in Lamayuru region. Out of those five, the present monastery of Lamayuru exists more or less in good condition. From the early ages itself, this monastery was regarded as a distinguished centre in terms of practicing spirituality. The King of Ladakh

and the emperor of Baltistan had once announced that even notorious criminal's offence would be pardoned if he payed a visit to Lamayuru and praed for mercy in front of Lord Buddha. This rule was not only applicable to Ladakh, but was also followed by the rulers of Kashmir too. In those days, had there been any dispute among the rulers of various states, they used to come to Lamayuru to find an amicable solution in front of Buddhist Lamas.

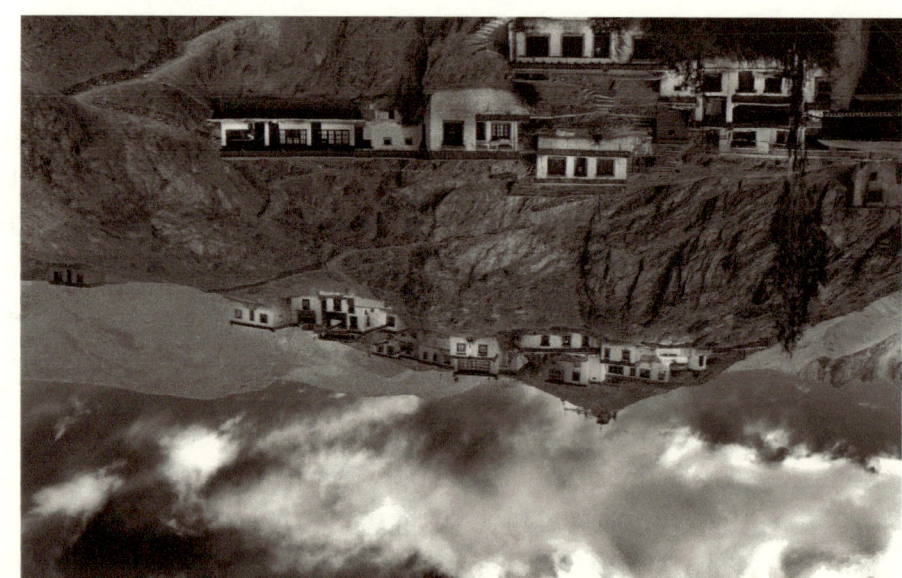

Chapter 13: Land of Broken Moon

If you now move a little bit towards the East from Lamayuru to Leh, you would find the landscape of world famous mountains of moon. From this point onwards to Ladakh, nature starts unveiling its colour-feeling-sound-touch in the form of beauty. The surface of the brown-yellow-blue barren mountains are covered by inexplicable abstract sculptures, hardly any greeneries are seen in this region.

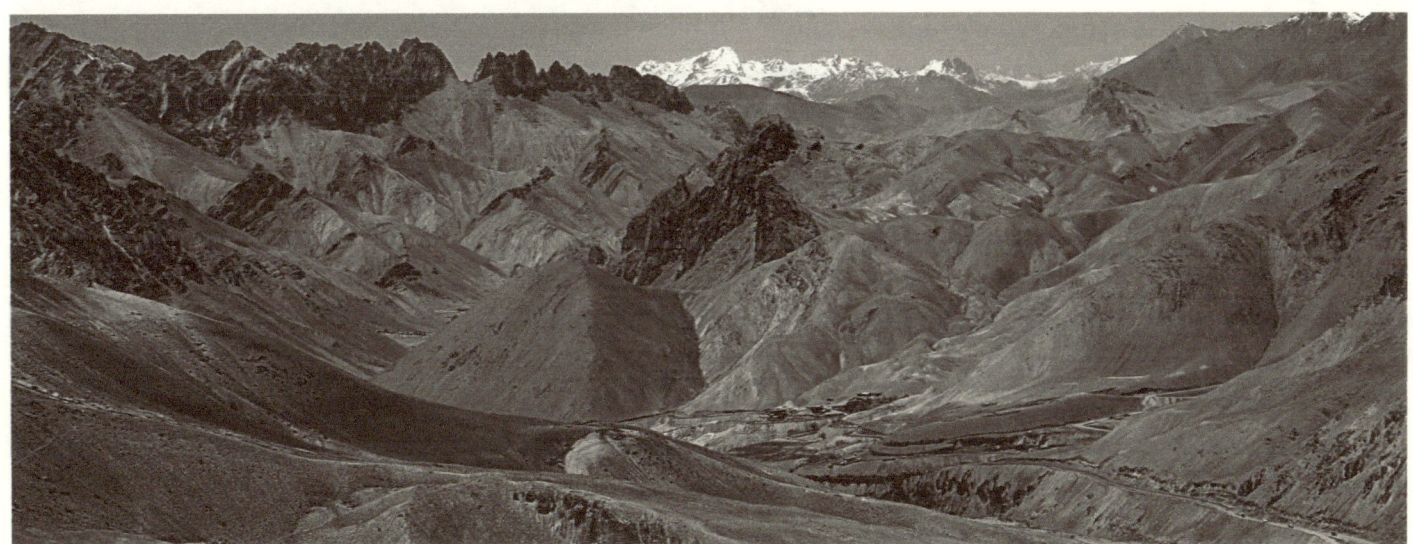

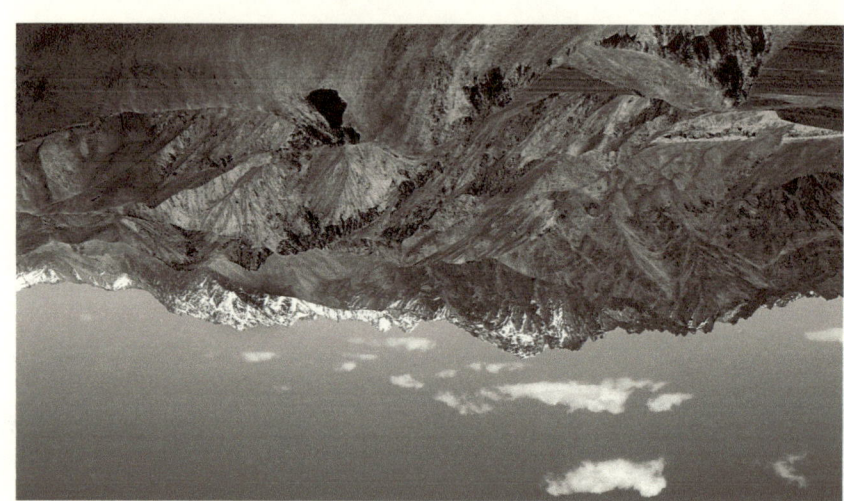

If you want to find out its root from history & geography, you have to go back many centuries ago, at the time of Shakyamuni Buddha. It was already described earlier; this region was merged under deep water at that point in time. The mountains woke up by the rigorous meditation of Mahashddhacharya Naropa. That is how, the entire Ladakh and its old heritage Lamayuru came up. No matter what flock-tales say, the existence of water body in this region was re-established after discovering the fossils of aquatic animals. The scientists say, strong wind blew and hits on the 'Aluvial' deposited on the mountain surface continuously over the ages. That is how, endlessly getting engraved during many thousand years, these unbelievable abstract natural-sculptures were created on the tree-less bare mountains. These magnificent mountain ranges have touched the sky crossing over the horizon. In these mountain ranges you would not get the signs of trees, animals or any kind of flora or fauna for that matter. These mountains bear a resemblance to surface of the moon. As if, a piece of moon had slipped off on the earth from the sky just by chance. No matter in what name Ladakh is being called, it is most popular by the name of 'Land of broken moon' to the rest of the world.

Chapter 14: Khalse-Saspole

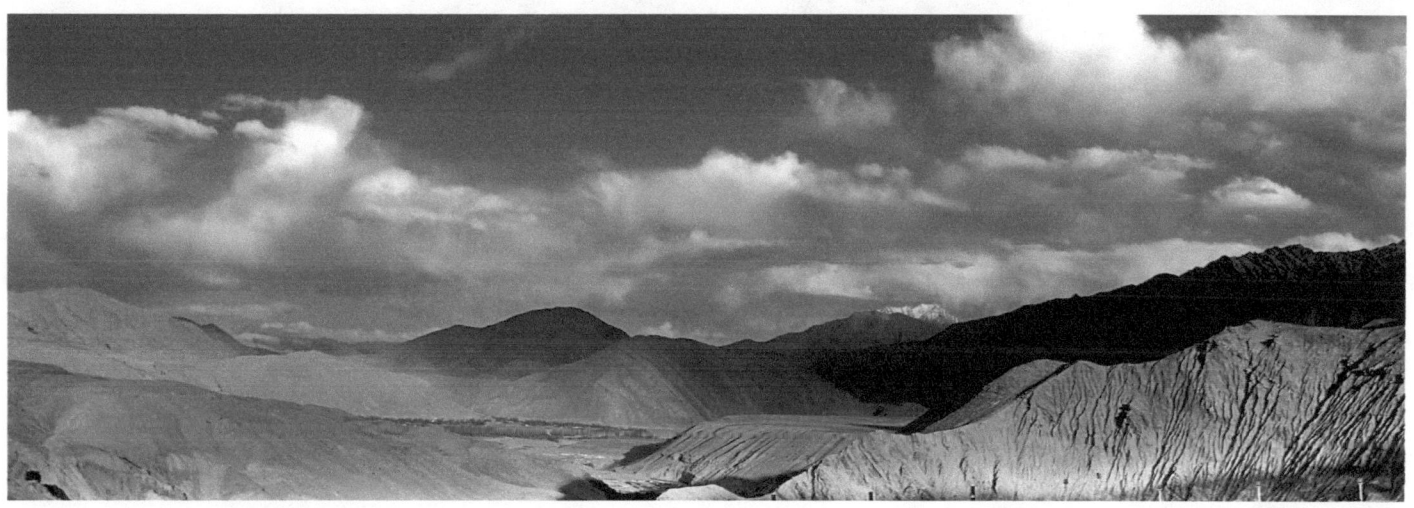

After crossing moon-land the road goes downward. In the right hand side there is a deep gorge and on the left hand side there are varied craftworks on the grey coloured mountain. On the road, suddenly you may find a locality, a few shops, the passers-by or the innocent and simple faces of the kids. The 'scenes' are getting transformed to a new one on every turn of the spiral road. A new image would appear on the large screen of nature that is in no way comparable with the earlier one.

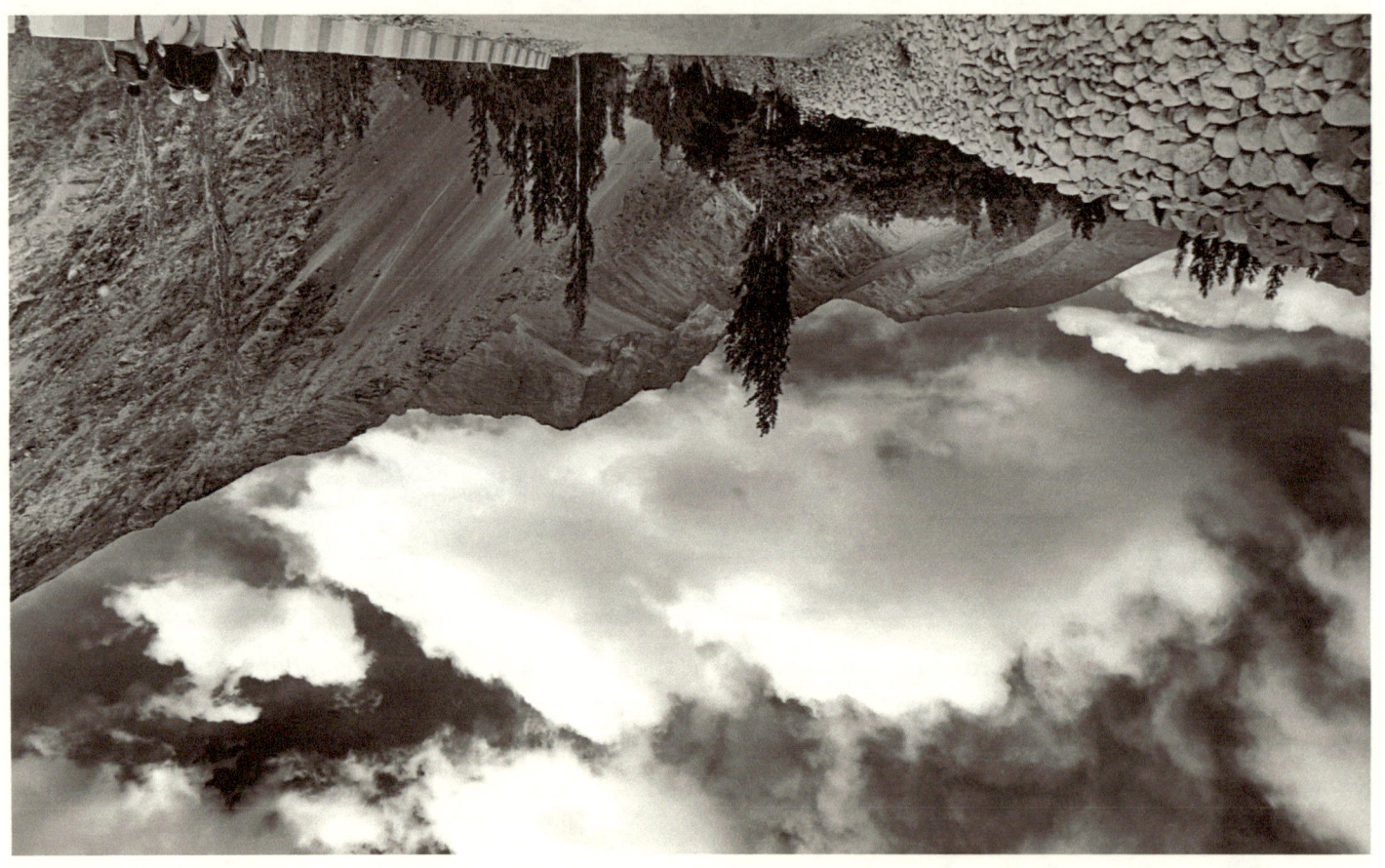

Chapter 15: Alchi Monastery

The Alchi Monastery is situated on the southern side of the Indus river over ten thousand feet on top of the hill. Tibetan translator and Prophet Rinchen Zangpo had built this prayer-centre approximately in the year 1000 along with Lamayuru and other monasteries. At the entrance, there are Poplar trees in a row, the old Ladakhis believe that these trees were created from the walking stick of Zangpo. The Alchi monastery is basically divided into three sections - the main temple, Dukhang, meaning prayer hall and Manjushrree temple. The main temple is three-storied, crafted with excellent artwork. This monastery possess some very old paintings of Kashmiri and Tibetan artists, this collection is one of the important and valuable discoveries of old art pieces from Ladakh. In these pictures, most surprisingly, the Tibetan Buddhist culture and the life story of Kashmiri kings have secured their positions, intermingled together. Rinchen Zangpo had engaged the Kashmiri artists for drawing pictures on the wall of all one hundred and eight monasteries he built but only the pictures painted in Alchi monastery remain intact till today. On the main temple's outer wall there are Mahakal and life cycle of Buddha is painted. The pictures of Dukhang are dedicated to Pancha Tathagata. Lord Buddha's life cycle is divided in six sequences and this is covered by four-headed Boirechen. Three famous statues of three life stages of Lord Buddha shine in this prayer centre - Maitriya, Abolokiteswar and Manjushree.

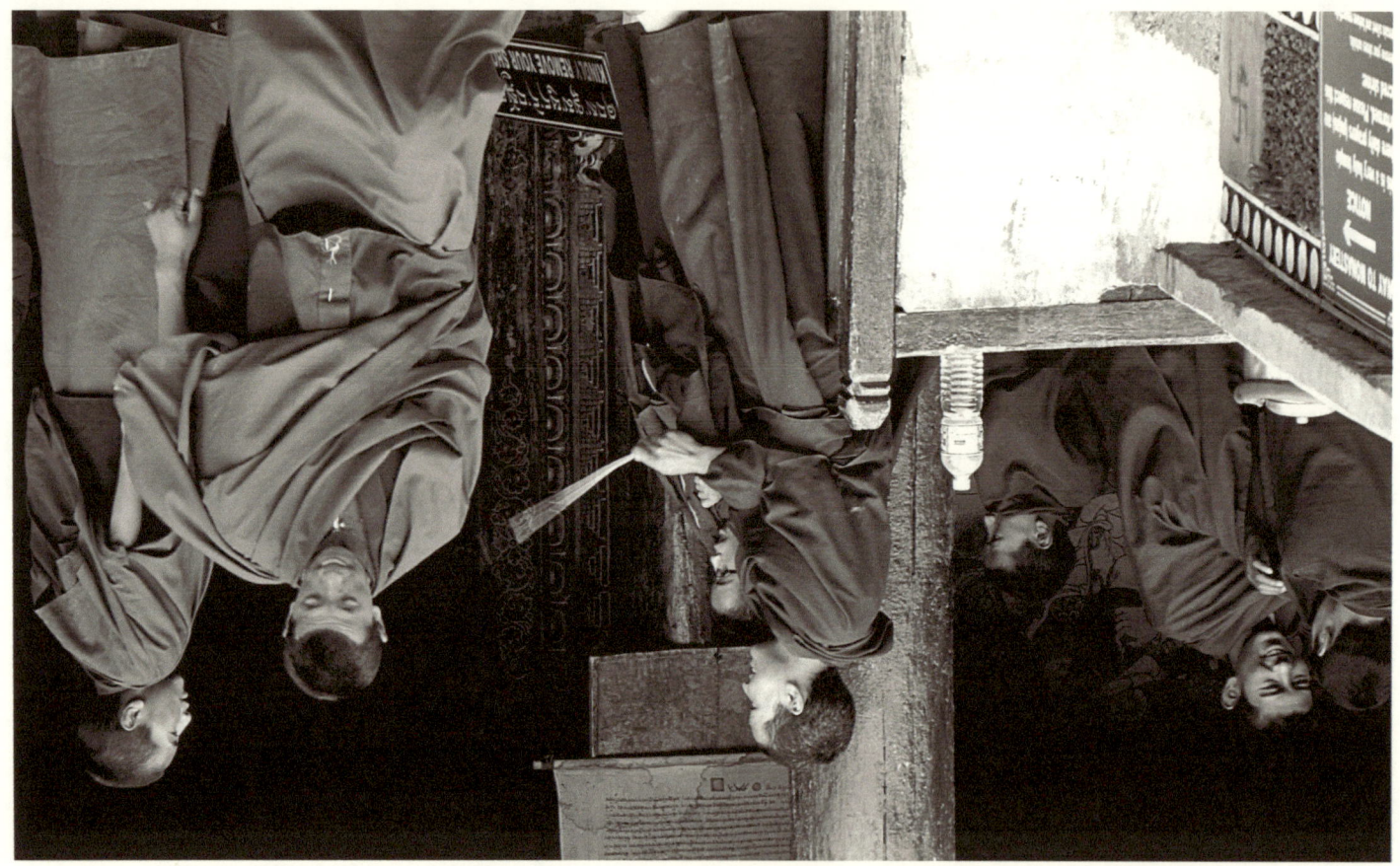

Chapter 16: The confluence of Indus- Zanskar

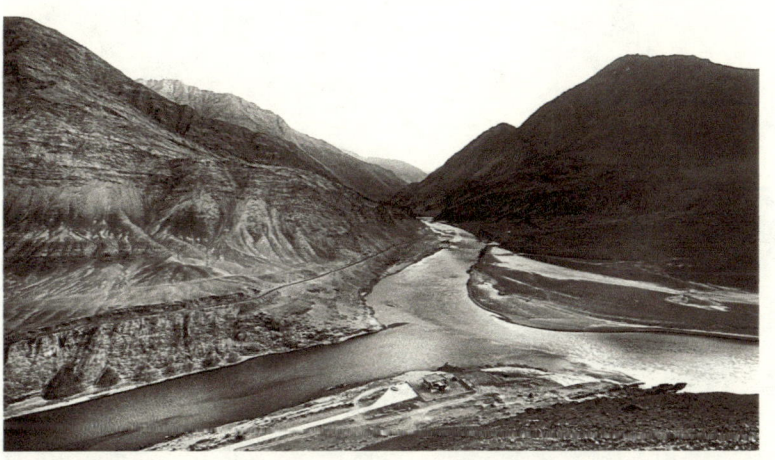

After crossing Alchi, the Srinagar-Leh National Highway approaches Nimu in a crisscrossed way. Nimu is a rich village. The distance from Leh to Nimu is 36 Kilometres. The importance of Nimu in Ladakh's geographical map is immeasurable. The historical Indus River and the Zanskar River flowing through Ladakh met together here, one would be able to distinguish the streams of two rivers clearly. The curtain of mountains have come down from the blue sky and the confluence beneath has created a picturesque landscape here. After Nimu, hardly there are any upward and downward trends: it is almost a plane land. In the surroundings, there are many colourful small peaks and mountains of different shapes and sizes. The horizon is covered by layers of snow caped pikes, raised their heads towards the sky.

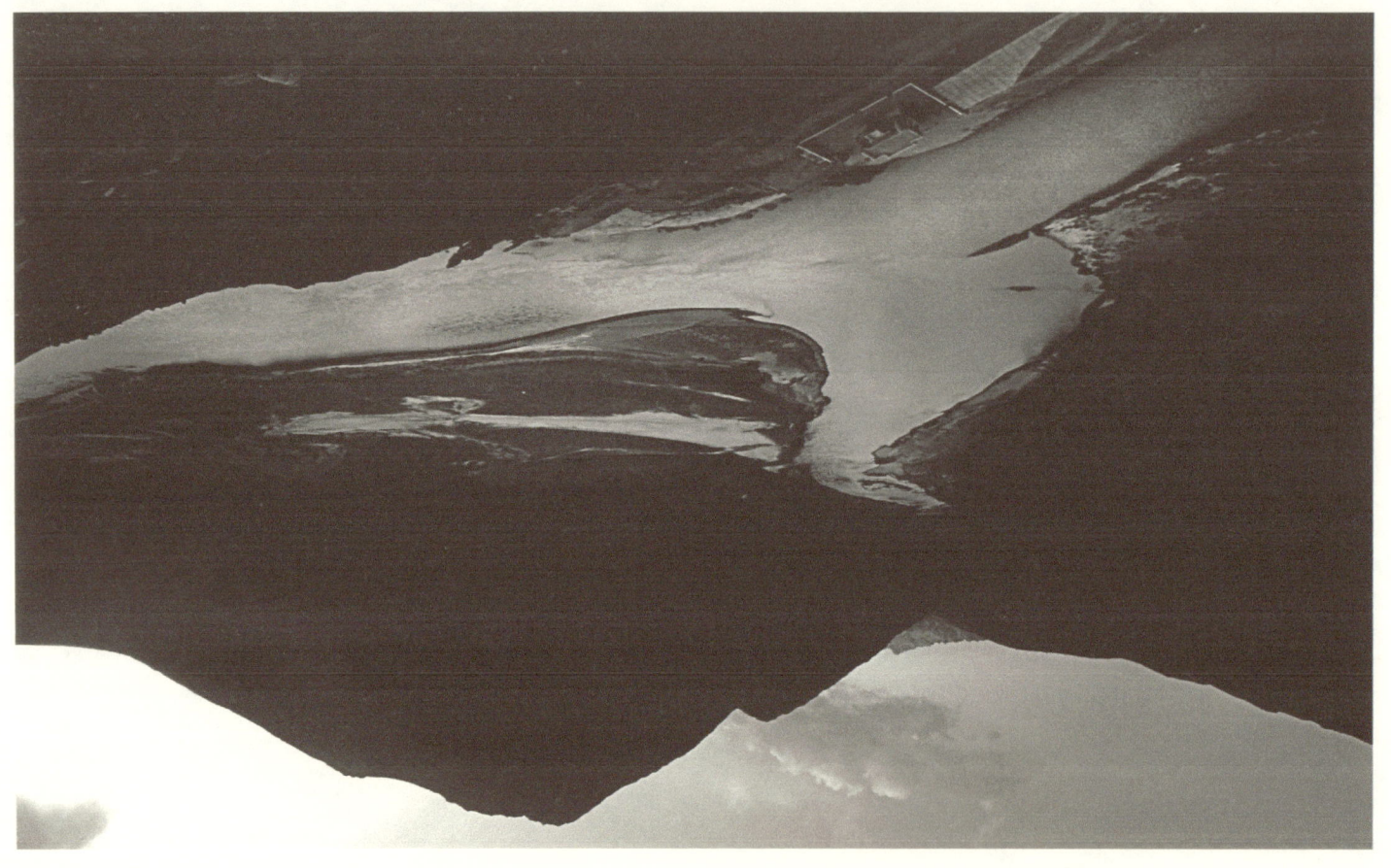

42

Chapter 17: Leh Town and its people

Statistically, Leh is the second largest district (45110 square Kilometres) in India after Kutch of Gujarat but the population of Leh is very less, just over 30,000 (in the year 2014). In August 2019 the Parliament of India passed an act that contains provisions to make Leh a district of the new union territory of Ladakh which is to be formed on 31 October 2019. Leh, at the height of 11562 feet, is a small hilly town. Alike the entire district, Leh is also a

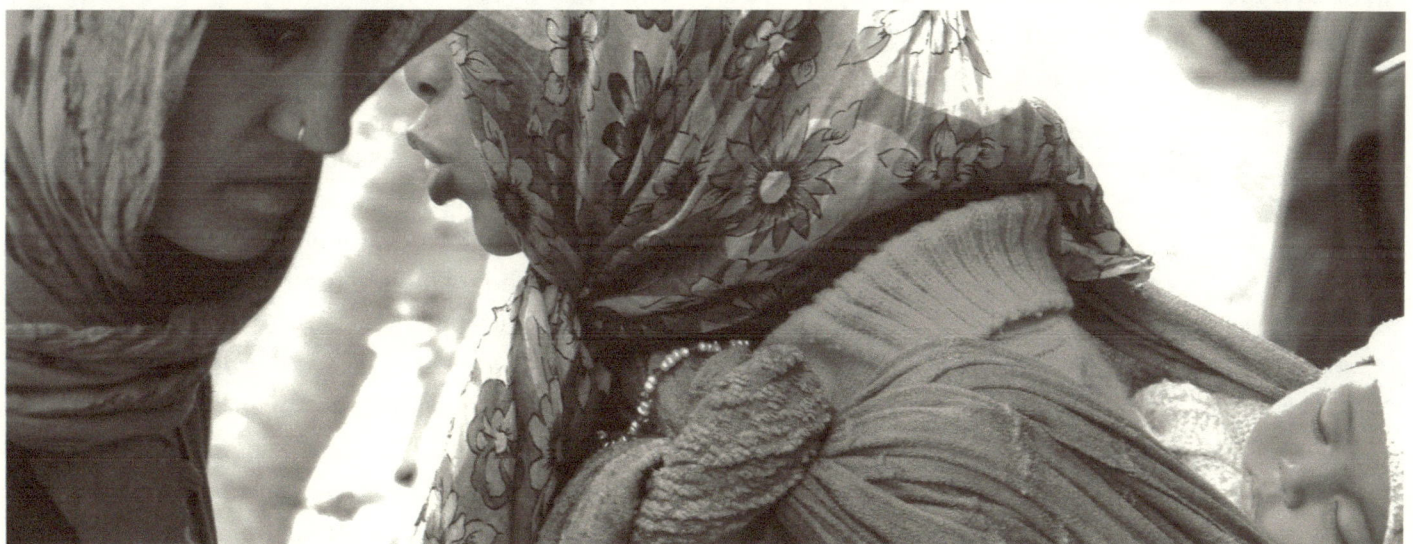

Although accurate history of those ages are not properly documented anywhere. Trading used to take place by using four-five main routes in those days. Apart from the old Manali and Srinagar Highway, Leh was connected by two other roads from Baltistan through Indus Valley. Other than these, there was a road from Leh to Yarkand, crossing Karakoram mountain ranges. Leh was also connected by road to Lhasa, the capital of Tibet.

Buddhist majority town, nevertheless, there live a few Christian and Muslim families as well. Leh was an important centre in the flowing stream of commercial activities in Indus Valley on those days. Keeping Tibet in the East and Kashmir in the West, Leh was the witness of many significant incidents of China-India trade route, for many centuries. There are several evidences which will prove that many years ago, even at the time of Kushana Empire, the Chinese traders used to take this route to establish business relationship with India.

Gone are those days, now in the busiest area of Leh, Main Bazar, various goods are sold like hot-cake. Apart from the commodities used for daily needs, there are shops for curio, home décor (in Tibetan style), beads, bracelets, bag, garments etc. Ample facilities like ATM, Foreign Exchange counters and even cyber cafe etc. are available in

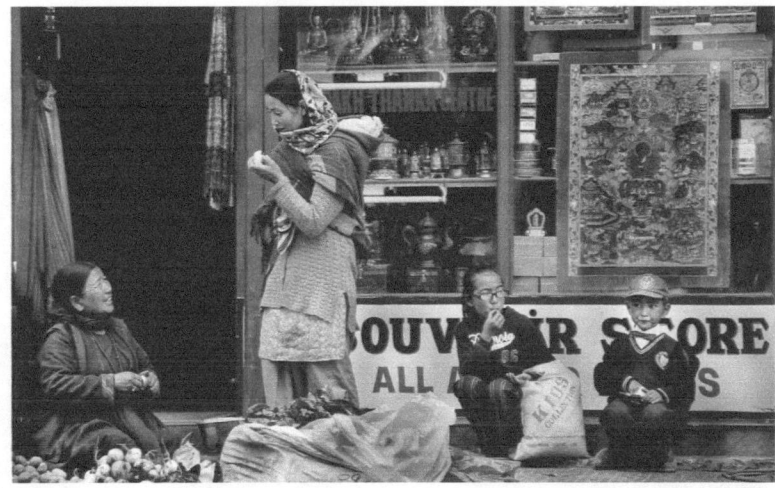

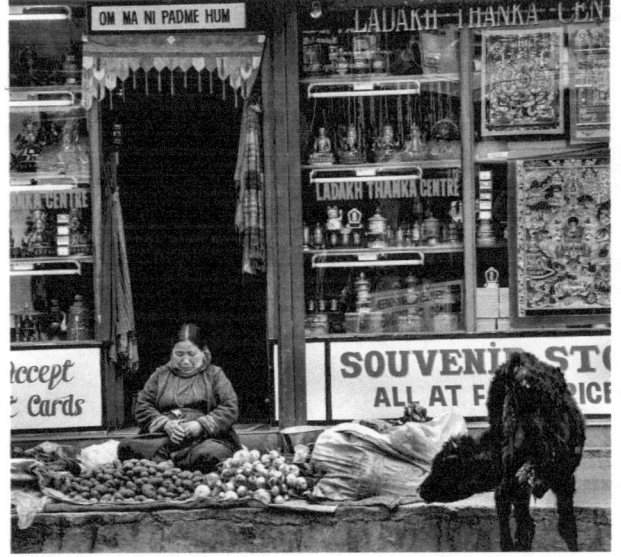

this market. Many foreigners and Indians roam around this place, among them most of the people can easily be identifiable as tourists.

Chapter 18: Hemis Monastery

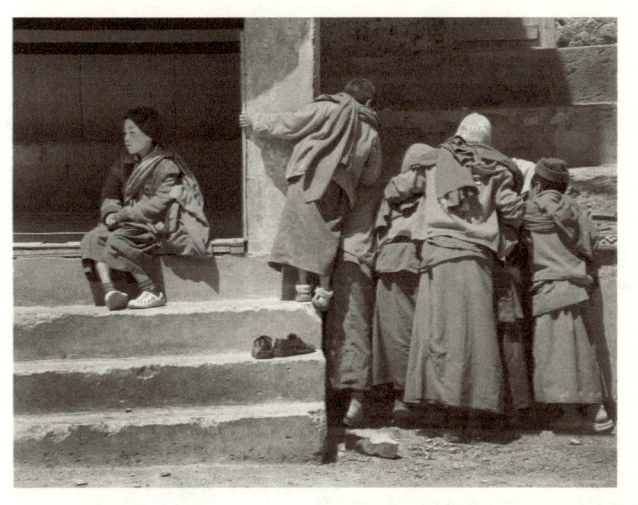

45 Kilometres from Leh, dignified Hemis Monastery is located on the opposite side of Indus river. There are evidences of Hemis monastery's existence before the year 1100 but this was re-established in its new form by Ladakhi king Senge Namgyal in the year 1672. An amazing view of the Indus valley is seen from the rooftop of this prayer centre.

Around 450 Lamas from Drokpa community stay here. Apart from this, Hemis has established its branches in nearby 50 villages where many Lamas live. Inside the monastery, there is a wide open courtyard where the Buddhist religion guru Padmasamvaba or Rimpoche's birth anniversary is celebrated in the month of June. As a part of the celebration, the Lamas dance excitedly wearing masks of gods and goddesses who are imagined to be the representatives of death. Wherever you look at, there is a sign of dignity and affluence in Hemis. They possess a very high standard museum and library. It is said that Swami Abhedananda came here once. It is also said that the life history of Jesus Christ is described in the old manuscript kept in the library. Some believe that at the time of hiding, this place was selected by Jesus as hideout. The starting point of

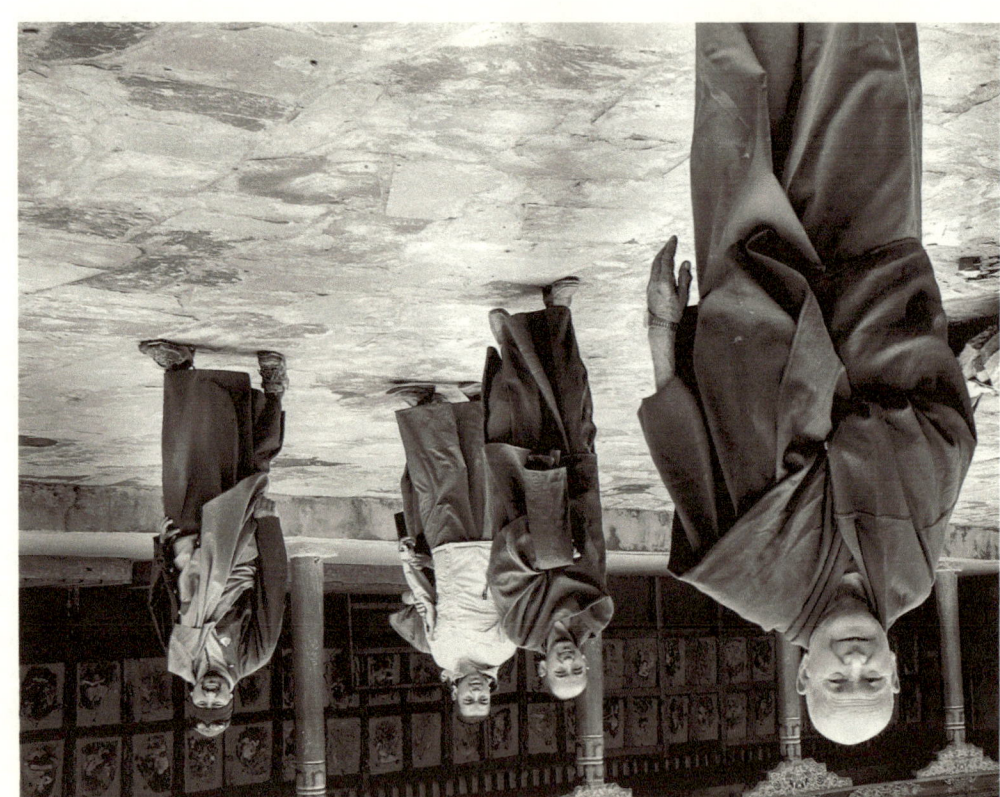

this belief lies somewhere else. In the year 1894, Necholous Notovitch, a Russian journalist was bound to stay here for some time for the treatment of his broken leg. He claimed that during that time the Lamas showed him some documents from their collections by which his belief got stronger. Afterwards, further research by other historians proved this theory to be wrong and Notovitch was bound to admit that the evidences he produced were somewhat exaggerated.

Chapter 19: Thiksey Monastery

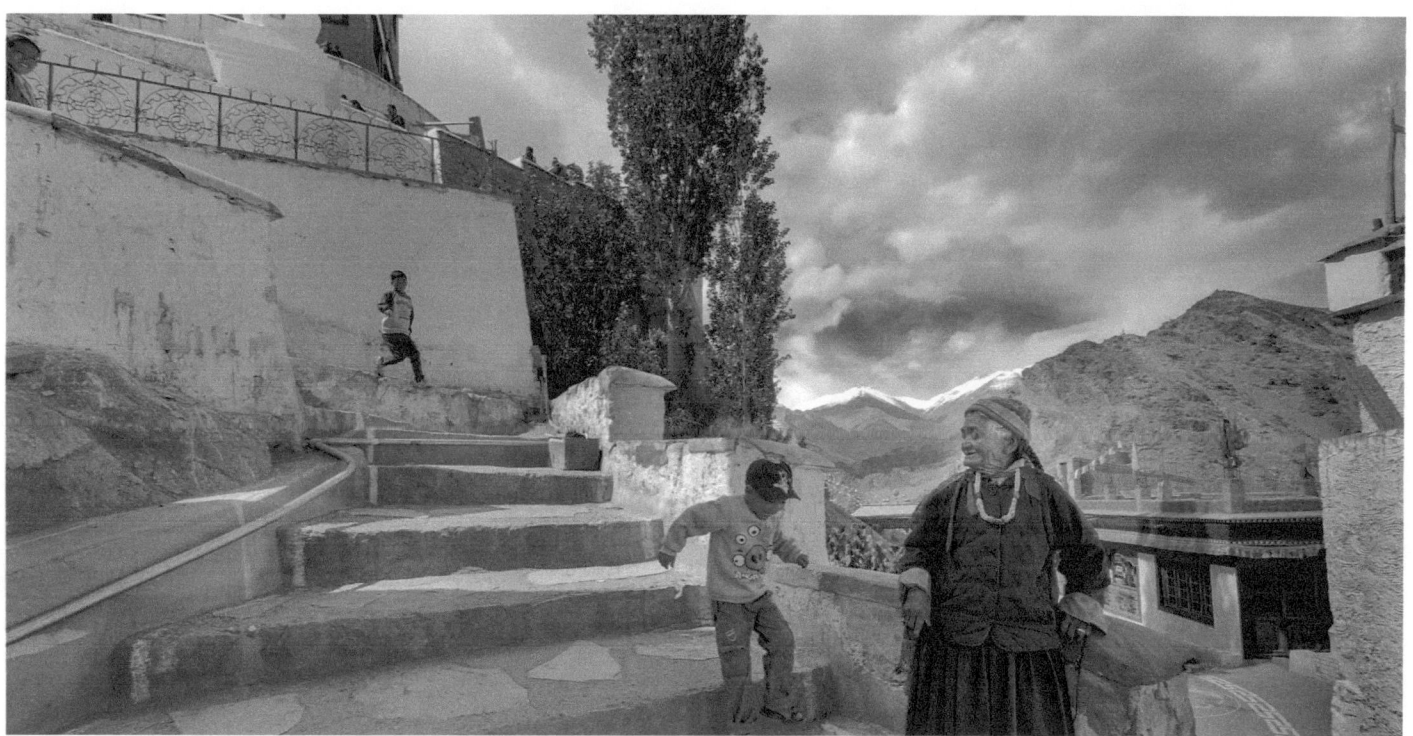

19 Kilometres from Leh towards East, Thiksey monastery was established in early 1500 on a mountain peak at 1800 feet amidst the fascinating beauty of nature. There have been so many evidences of Buddhist artefact preserved in this twelve-storied Buddha-temple. BuddhaStupa, Thanka, Statues, wall paintings, old knives. Each floor of this twelve-storied building is categorized according to the importance of work, from bottom to top. In the ground floor there are residential arrangements for Lamas, cooking facilities etc. while the top floor is identified to be the seat of the Chief Lama, Prayer Hall etc. The Thiksey monastery was constructed by replicating the Potala Palace of Lhasa, the Tibetan capital. This palace was the home for the earlier Dalai Lamas. The main attraction of this palace was a stunning Buddha statue of 50 feet. This statue was built in 1970 on the occasion of fourteenth Dalai Lama's visit to Thiksey. From the perspective of influence on the people, position of this monastery comes after Hemis. Thiksey monastery administratively handles activities of four other monasteries - Diskit, Spitur, Likir and Stok.

Chapter 20: Shey Palace

Shey palace is located 15 kilometres away from Leh on the Leh-Manali highway. This palace was the summer capital of the Ladakhi kings. This palace was built by king Deldan in the year 1655. Major portion of this palace is dilapidated now.

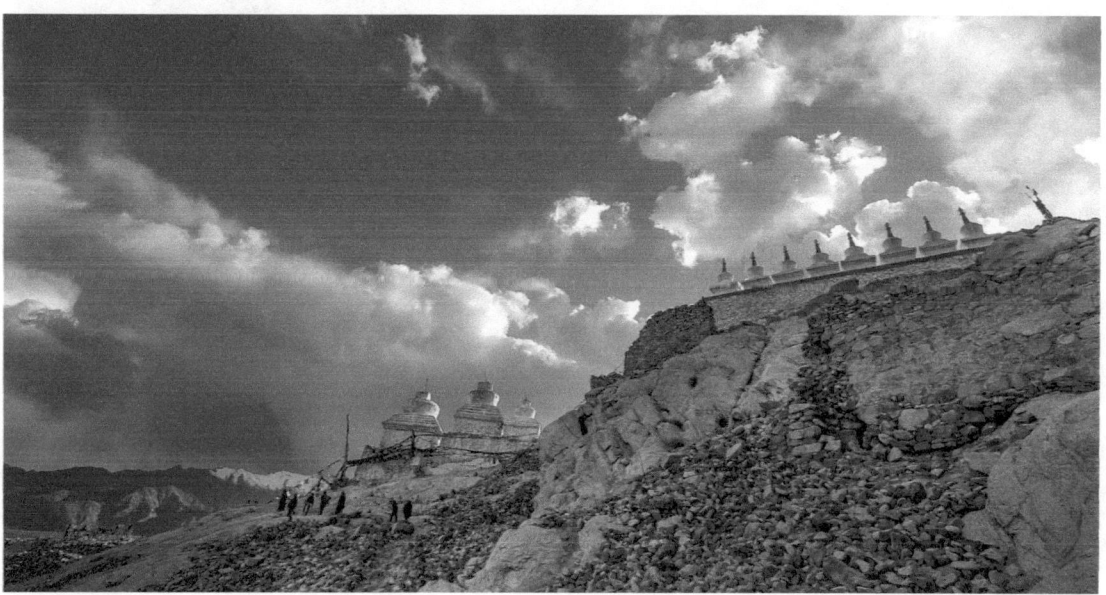

Once upon a time Shey monastery was built in the Shay palace itself on the memory of King Deldan Namgyal's father Singe Namgyal. One of the major attractions of this palace is the statue of Sakyamuni Buddha, made of pure gold. In a room on the upstairs, some magnificent

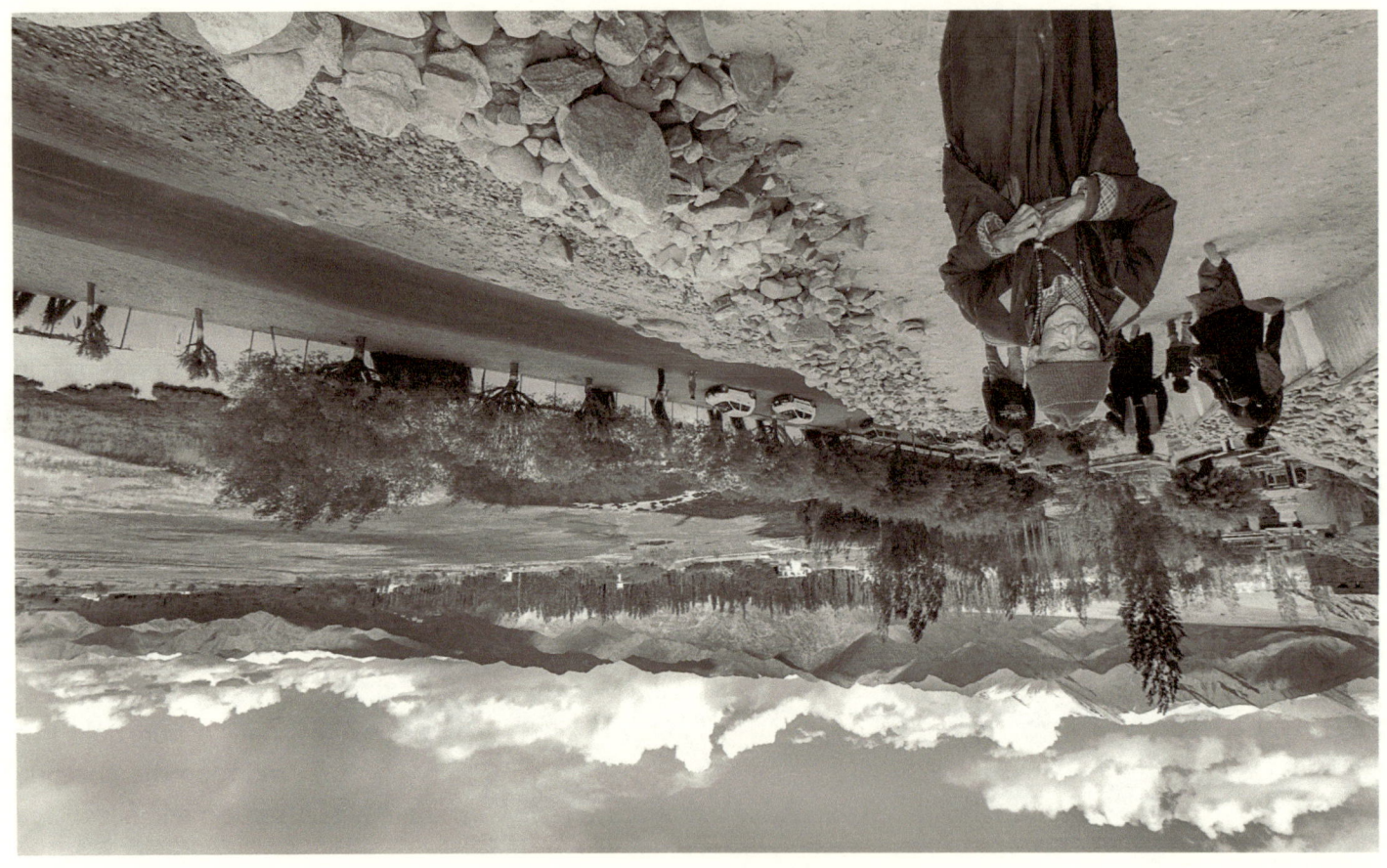

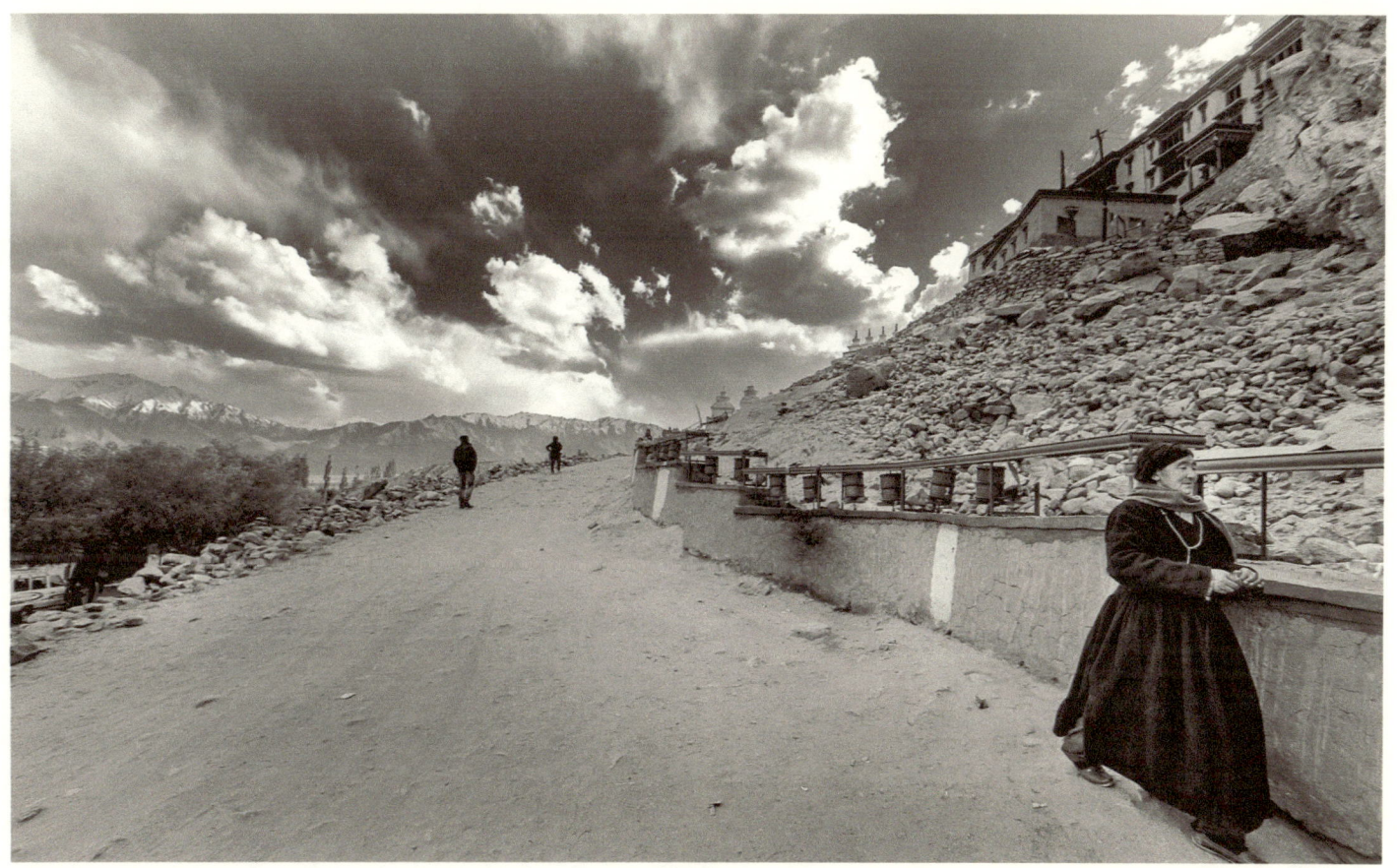

paintings were created by old artists while in the downstairs huge collection of Tibetan manuscripts are preserved. Most of the walls are covered by murals; various postures of Lord Buddha are illustrated through these pictures. From the top of Shay palace the lush greeneries of the Indus valley can be viewed. The 'grey' Ladakh is absolutely green here.

Chapter 21: In and around Leh

Leh had to wipe out its oldness due to the demand of being modern and pressure of developments. Like any other hill station Leh is also bit jam-packed with cars, shops, school-college, hospital etc. Very often than not it is seen that the mountains are getting cut by bulldozers. Is the uncontrolled destruction of nature by human beings caused the devastating flood following cloud burst in the year 2010? Or the much talked about global warming is responsible for that - Let scientists find out the answers! Nevertheless, if you come out a few steps from the town Leh, you will get a warm reception by the clean nature. Despite the dearth of oxygen, the sky is filled with only fresh air in and around.

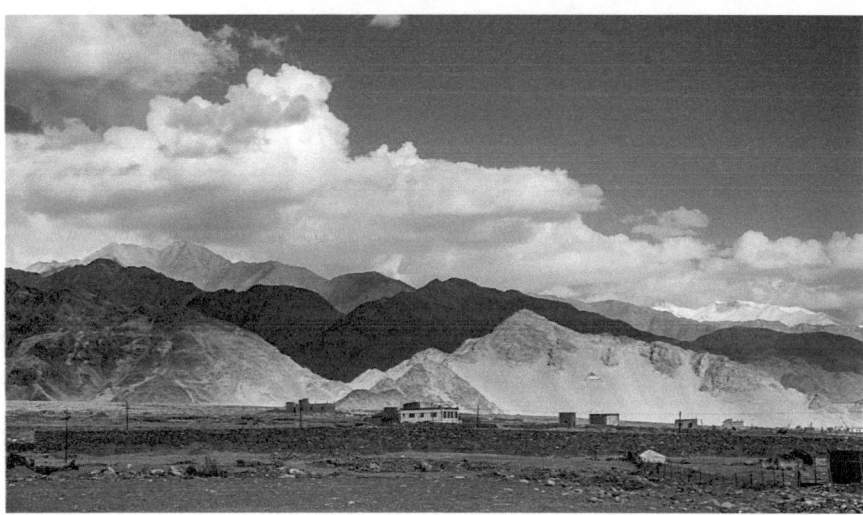

Chapter 22: Khardungla

Khardungla is 39 kilometre away in the north of Leh. Khardugla has connected Leh with two most beautiful Valleys of Ladakh-- Shyok and Nubra. In local language Khardungla is called 'Kharjongla'. Distorted like any other Tibetan words, the highest motorable pass of the world has become famous as 'Khardungla', thanks to the European tongue. It is anybody's guess if there is any other place in the world that is as beautiful as Khardungla where one may travel by car.

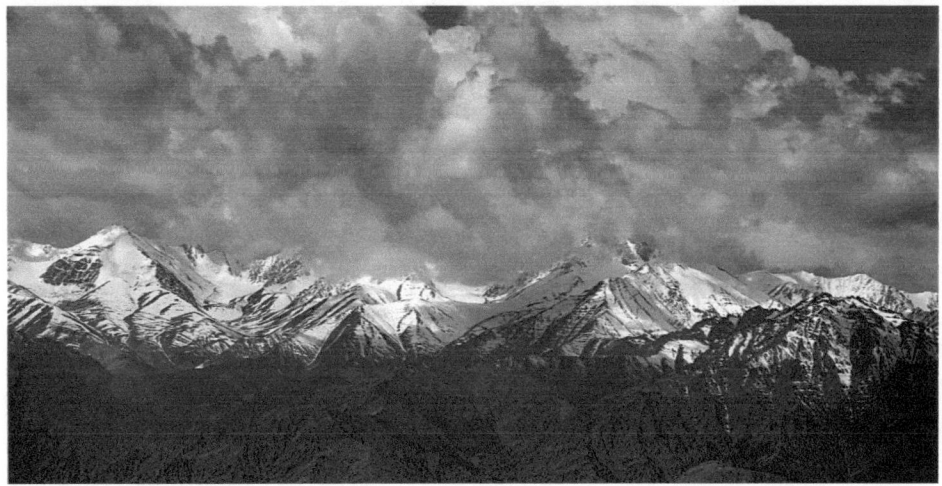

Though Indians have put the crown on Khardungla's head as the "highest motorable pass of the world" (proud announcement glitters on a plate at the highest point), but a lot of controversy prevails around this honour. Modern research arguably reveals its height to be 17852 feet! If this be true, then Khardungla has to acknowledge its defeat on being number one!

Whatever be the height, there is no controversy on one thing- the unbelievable diversified beauty of its nature. Cloud, mist, sunlight and snow play here all time with Karakoram mountain range in the north and Zanskar mountains in the South-west. At times, Khardungla has to bear the whimsical behaviour from the nature.

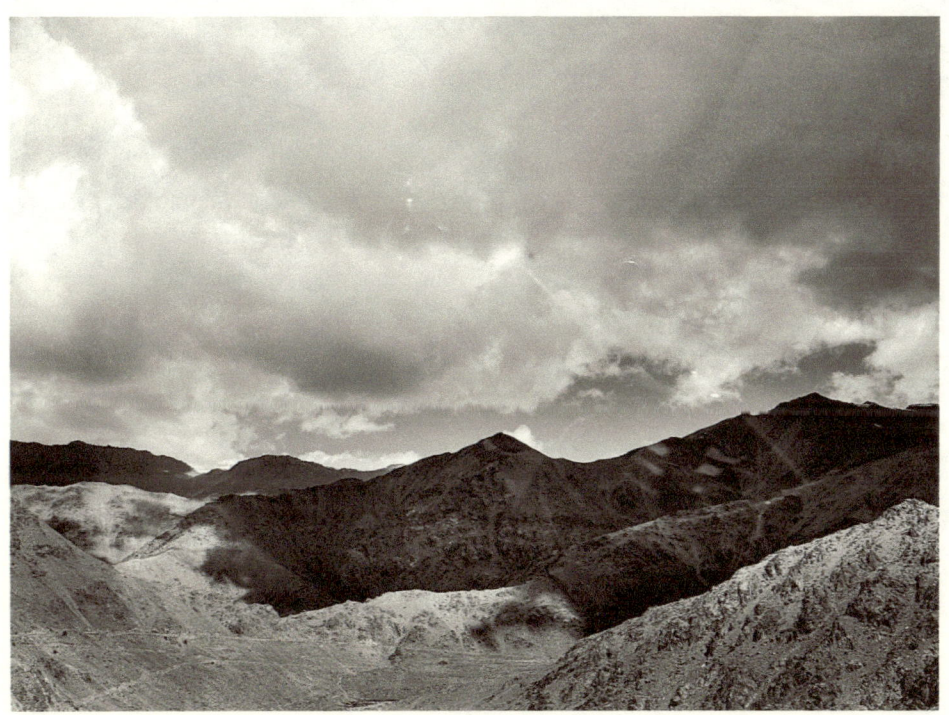

The present road of Khardungla was built in 1976, and it was released for public usage in 1988. In those days, this road being a part of the famous caravan route, Leh had connected Kasgar of Middle-East Asia. Almost ten thousand horses and camels used to commute through this route in a year. Now this road is mostly used by bikers for expeditions. More often than not, it is seen that the bikers with their motorbike and cycles are passing through this chilled, dangerous and impenetrable roads.

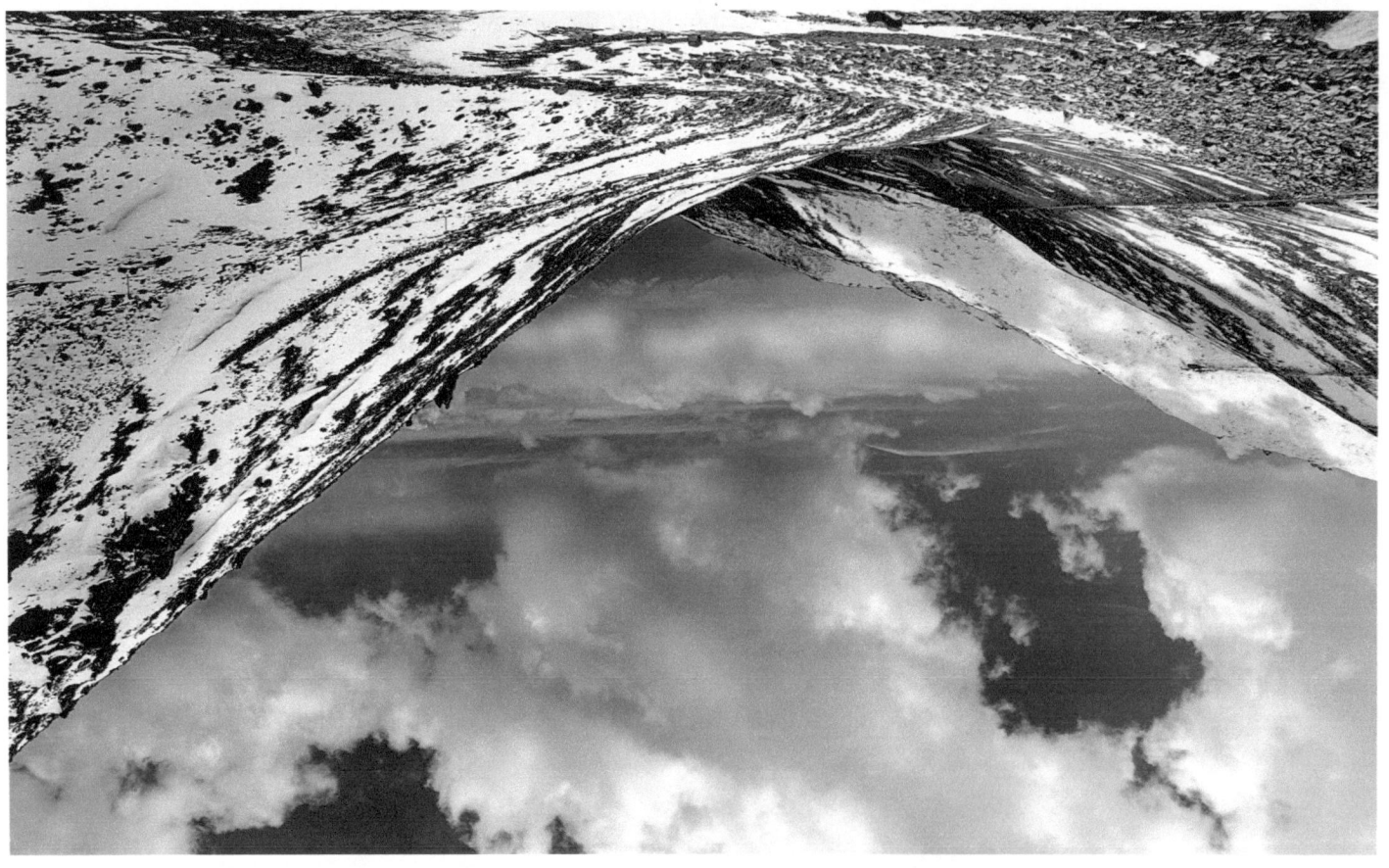

Chapter 23: Nubra Valley

After crossing Khrdungla, if you come down a little bit through the downward road towards North-East you would discover a small locality – Khalsar (10,060 Feet). Just after Khalsar, the confluence of Shyok and Nubra river could be seen. The landscape is a pleasure for the eye. Nubra river, nourished by the ice-water of Siachen glacier and Shyok river, a branch of Indus river intermingled here and created two huge valleys. The names of these valleys are by the name of the rivers themselves- Nubra and Shyok. These valleys have separated Ladakh region and the Karakoram mountain ranges. The intermingled stream, namely Shyok entered Pakistan and became a tributary of 3000 kilometres long Indus river. Like many other regions of Tibet, Nubra Valley is a cold desert

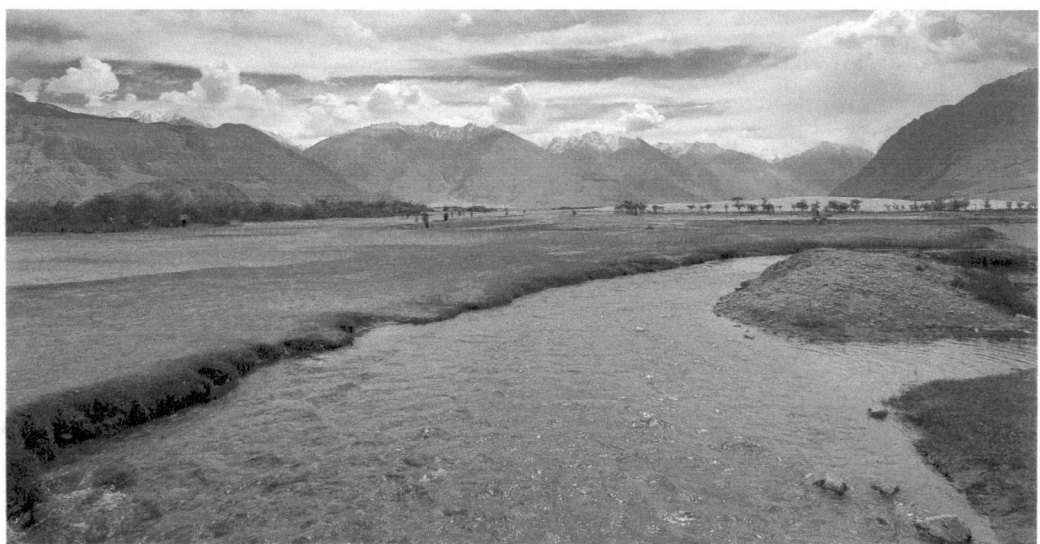

in high altitude. In spite of that the villages beside the river are considerably fertile. Wheat, Barley and many other vegetables are produced here. Red Apple and Apricot are predominant among all these. Compared to the harshness of Ladakh's nature, this area is exceptionally green. By the bank of Nubra river there exist some famous villages - Sumur, Pyanamik, Tirikh, Turtuk, Khaygar. Khaygar is called as 'Tiger' by the Indian army, Panamik possesses a hot spring. The famous trade rout came and met on the other side of Panamik that was spread from Yarkand of middle East Asia up to northern part of India till 1950. The Road from Baltistan to Nubra was also closed in 1947.

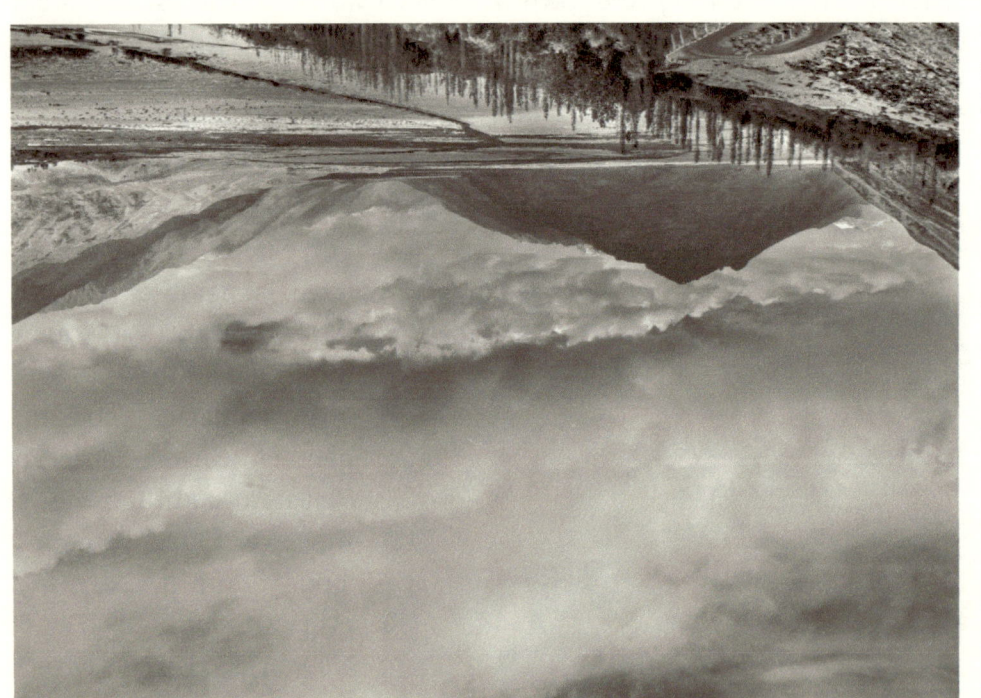

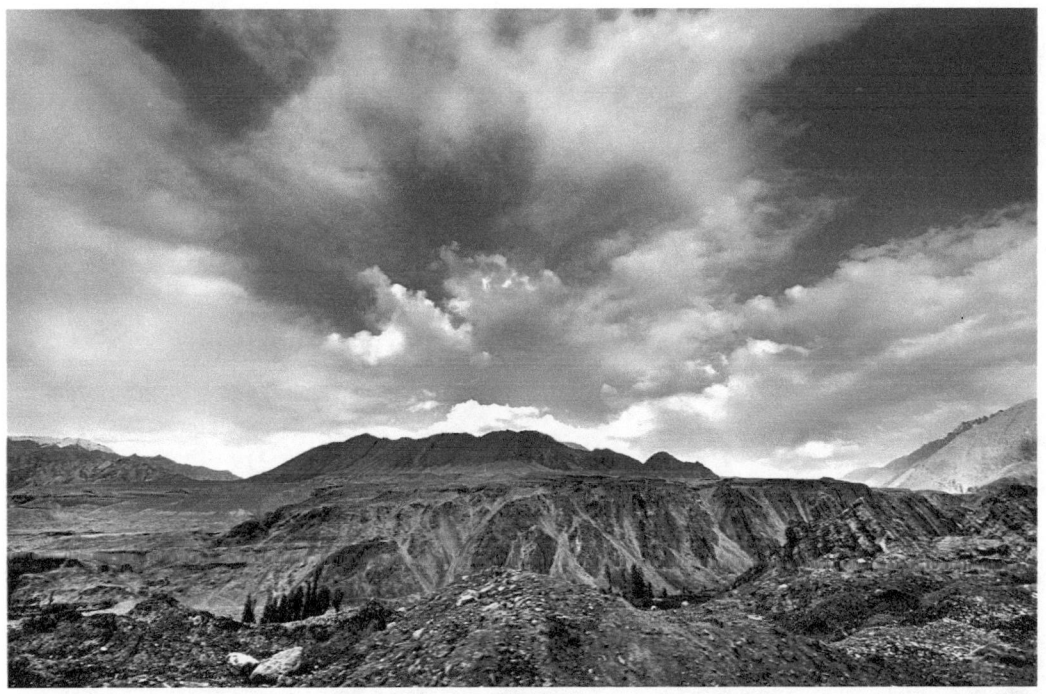
The famous Siachen Glacier is situated in the north of Nubra Valley in India-Pakistan border at 18,875 feet. This glacier is the highest battle field of the world. Before 1984 this glacier was really deserted. Now, this has become an important battle centre for both India and Pakistan for its strategic location. As a result of rivalry between these two countries, this glacier is alarmingly getting squeezed in shape and size and the impact of which would surely come down heavily on the ecological balance of nature in in the near future. Apart from death due to war, many soldiers from both the countries have been losing the battle for their life, after fighting against the extreme harsh and cold environment of Siachen Glacier.

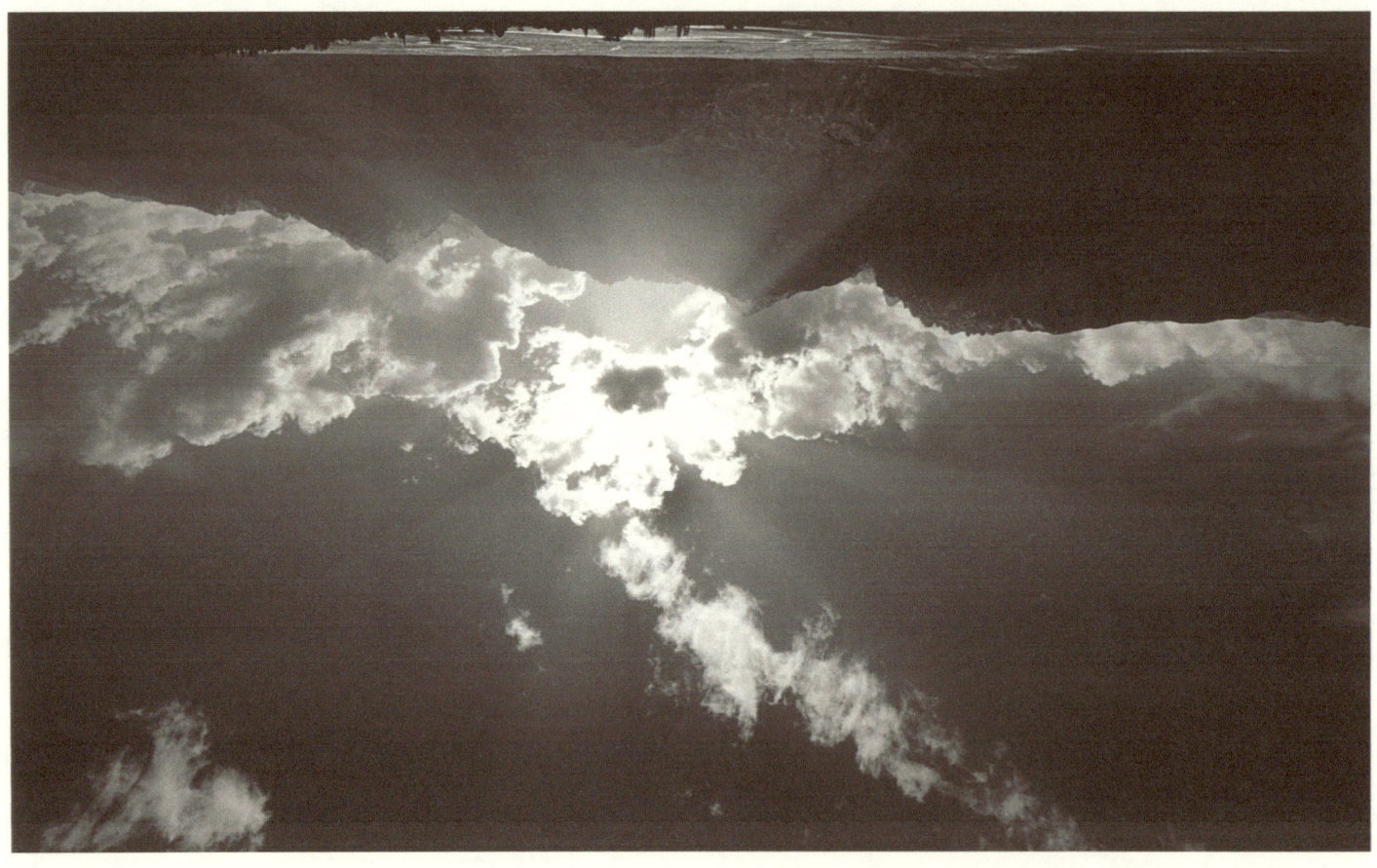

Chapter 24: Diskit Monastery

If Nubra Valley is considered to be the crown of Ladakh's natural beauty, surely the gem glittering on the head of the crown is Diskit Monastery. Contrary to the dry nature of Ladakh, Diskit is covered by the shadows of Apple and Apricot trees -a sheer pleasure to your eyes. Thanks to the greeneries, Diskit is often called as 'Ladakh's orchard'.

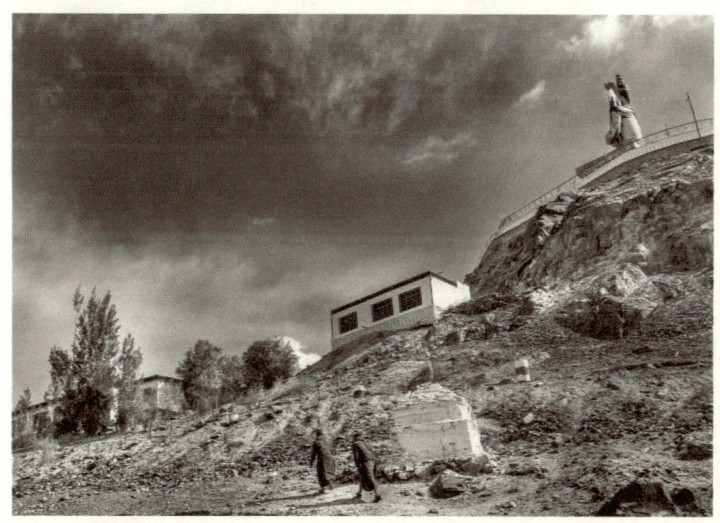

Diskit can of course be distinguished by the Diskit monastery built by Tibetan Buddhist community Golupa, who wear yellow cap. One of the major icons of this monastery is 106 feet high Buddha Maitriya Statue erected at the top of monastery. This statue is visible well before entering the monastery.

Here Lord Buddha is looking straight at Pakistan over Shyok river. The construction of this Buddha statue was started in 2006 and was inaugurated by Dalai Lama in 2010. There were three major reasons for construction of this statue- One, Protection of Diskit

courtyard, a picturesque view of Nubra Valley can be seen from here. looking statues of God and Goddess of Death are preserved. Before entering the main temple, there is a wide of the inner rooms, terrible looking statues of God and Goddess of Death are preserved. Before entering the main temple, there is a wide courtyard, a picturesque view of Nubra Valley can be seen from here.

Diskit monastery is also connected with the tales of old Mongolian mythological stories. It is said that a demon who used to hate Buddhist religion lived here. He was killed many a times but came back here time and again taking incarnation. Lamas believe that this demon's head and hands are buried under the Diskit Monastery. In one of the inner rooms, terrible looking statues of God and Goddess of Death are preserved. Before entering the main temple, there is a wide courtyard, a picturesque view of Nubra Valley can be seen from here.

and wellbeing of people. Two, end of war with Pakistan and Three, maintaining of world peace.

Diskit monastery is also connected with the tales of old Mongolian mythological stories. It is said that a demon who used to hate Buddhist religion lived here. He was killed many a times but came back here time and again taking incarnation. Lamas believe that this demon's head and hands are buried under the Diskit Monastery. In one

Chapter 25: Cold desert

About eight kilometres away from Diskit there exists a wonderful place - its uniqueness is somewhat unparalleled to any other place of Ladakh. At one side of the road, there are mountain ranges, on the other side there is a barren land, south-bound Shyok river is flowing here. In between, there lies a desert, full of sand. Camels - the Ship of Deserts are also found to be roaming around. But these camels are little bit different from the general species of camels - these are double humped 'Bactrian' camels. Sand dunes and thorny bushes are seen around, whose formal name is 'sea buck throne' - as if a bit of desert was cut and placed at Nubra Valley.

This place is known to be Hunder. In seventeenth century, Hunder was the capital of Nubra state. In British ruled India, the yaks and camels were used to carry goods through the caravan route to Tibet and Turkistan. After

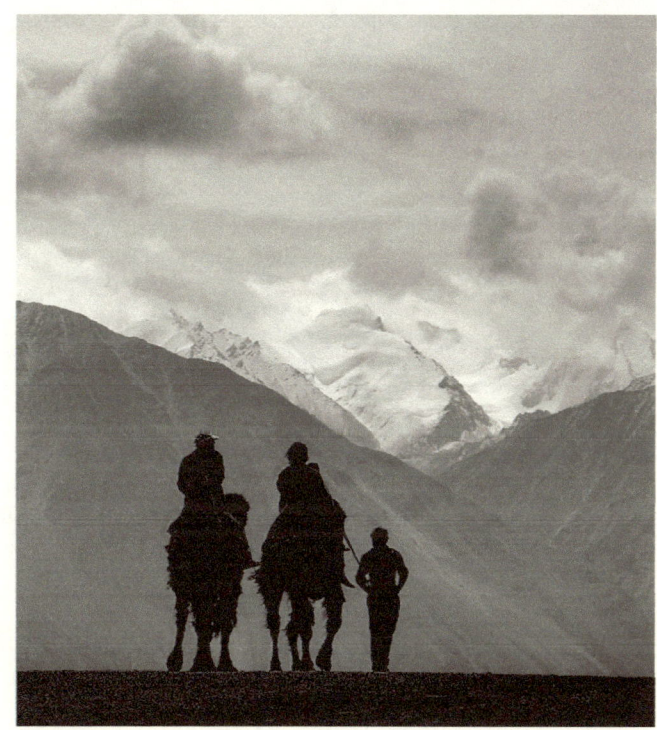

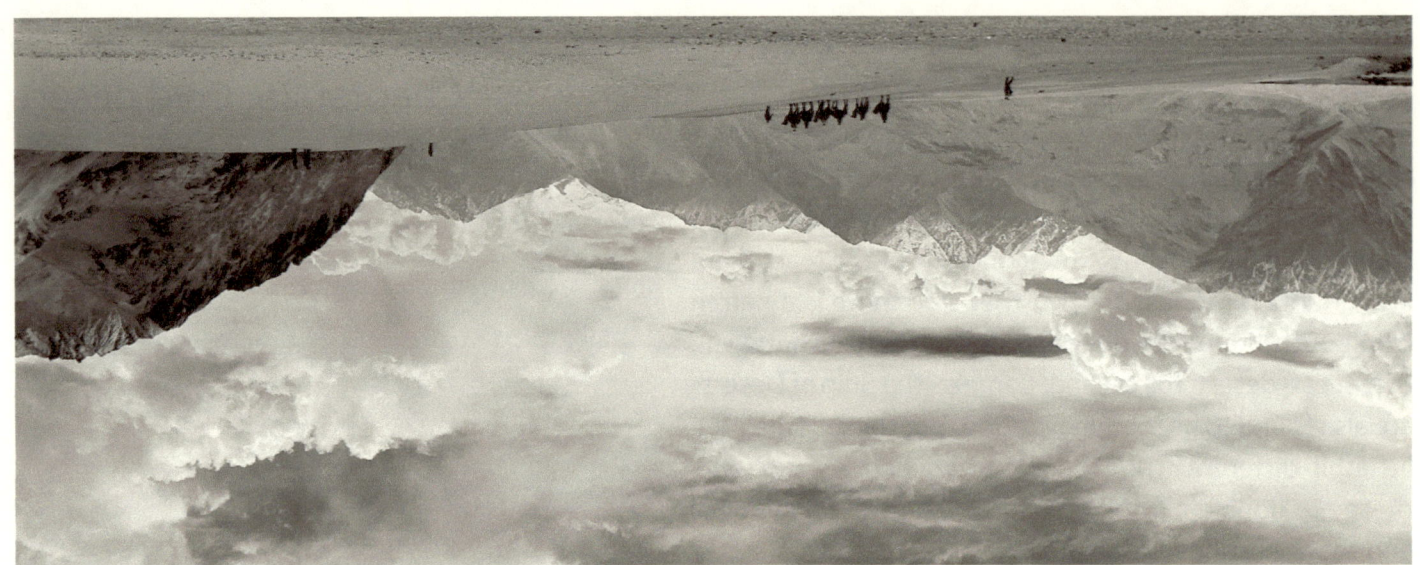

The Hunder village is like an oasis in a desert, small garden and plantation are seen in the front of each and every house here, trees are full of apples and apricots. This place is called Ladakh's 'Valley of Flowers' for this extravaganza of greeneries.

partition of India, even in 1967 before the India-China war this commercial route was being used. The camels which are seen here now, it is said to be the successors of the camels walking through the trade route on those days.

Chapter 26: Samstanling Monastery

Samur is another beautiful village of Nubra, touch of greeneries are also seen here. Samstanling monastery has made Samur village famous. This prayer centre is an embodiment of the tradition of Buddhist Mahayan religion. In 1841 Buddhist monk Nima established this monastery. The red stairs, covered by the shadow of Apple, Poplar, Olive and Apricot trees takes you straight to Dukhang, the main temple.

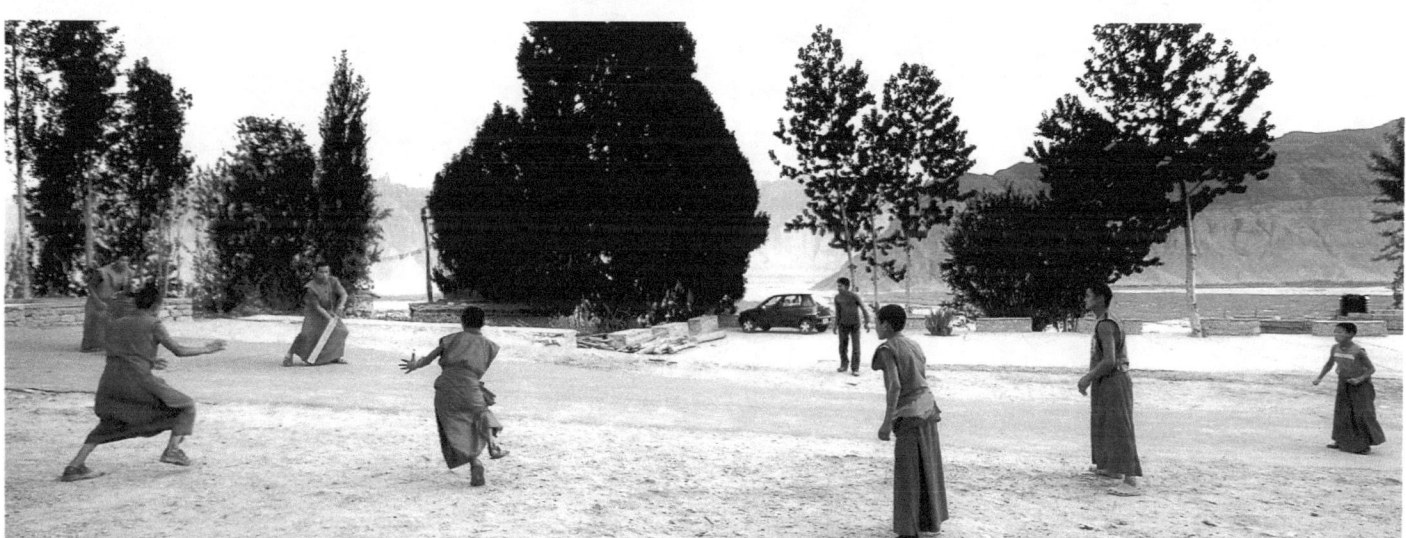

On the top, there are rows of prayer flags. In Dukhang, many old paintings are hung while the surface of the temple is coved by murals--- life of Gautama Buddha and his teaching styles are described there. In the outside of this monastery, you find an open ground where, the young Lamas are seen engrossed in the battle of sports, especially cricket.

Chapter 27: Changla

If you move around 35 kilometres straight through Leh-Manali Highway, you would find Karu. After Karu the road gets curved on the left hand side towards Pangong Lake. In this route there comes the 17,586 kilometre high Changla Pass, which is the third highest motorable pass in the world. While passing through Changla Pass, suddenly diversified greeneries are seen amidst the dry Ladakh mountains. Name of this village is Sakti. In Tibetan language, the literal meaning of Changla is "a road towards south".

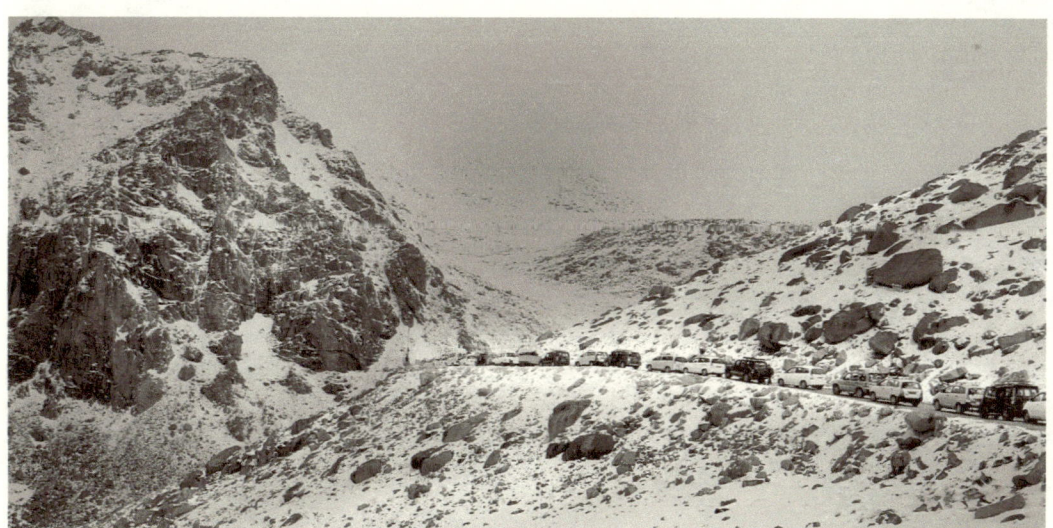

This road is bent to Tangshe towards South indeed. This route is very landslide prone, many a times a snarl of cars are seen getting stuck due to landslide.

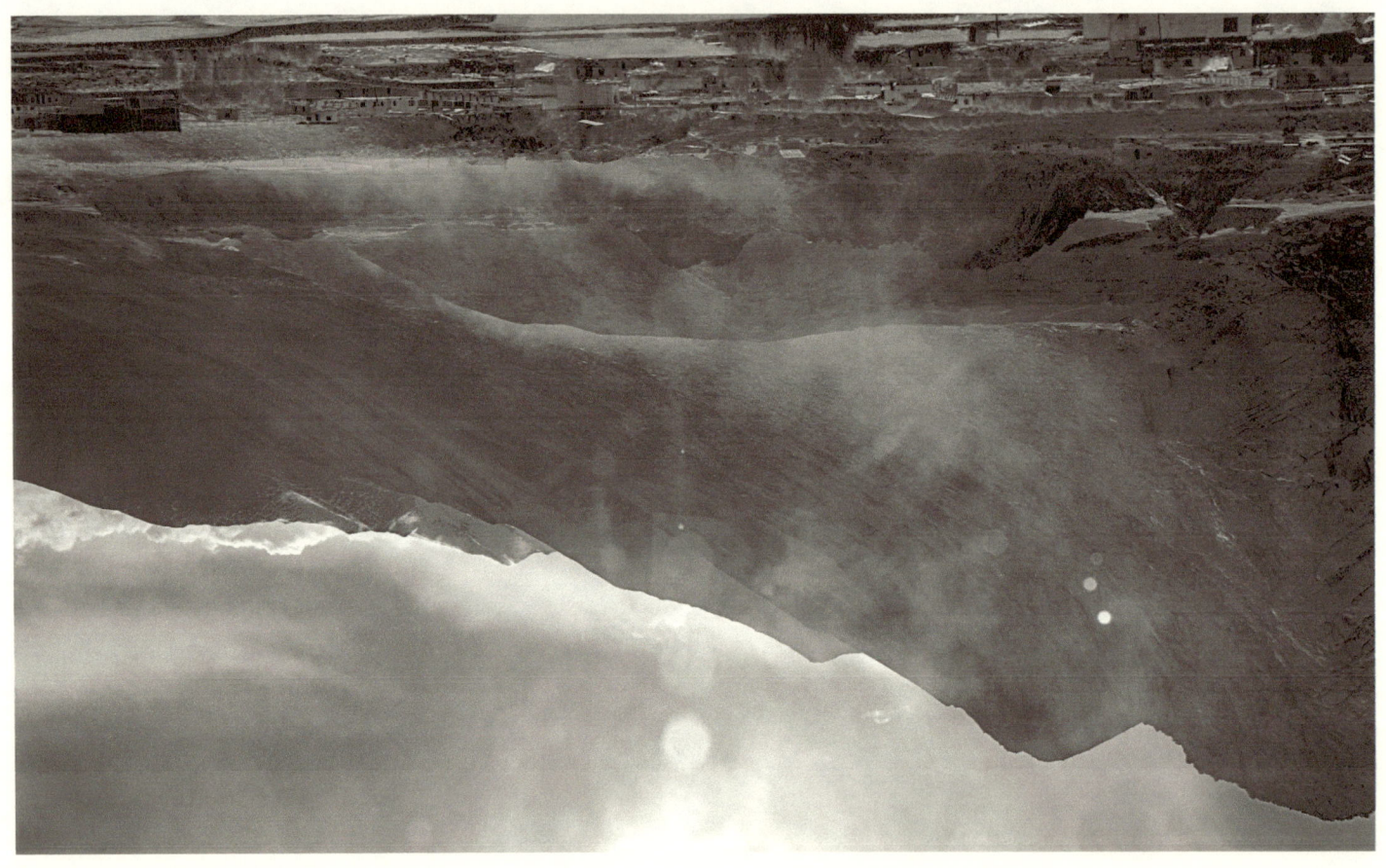

Chapter 28: Pangong Lake

Amongst the spots, for which Ladakh is adored by the nature-lovers from all corners of the world, the Pangong Lake is best one undoubtedly. The 134 kilometre wide lake at the height of 14,270 feet, is a wonder of nature, protecting the southern part of Ladakh with her stunning beauty.

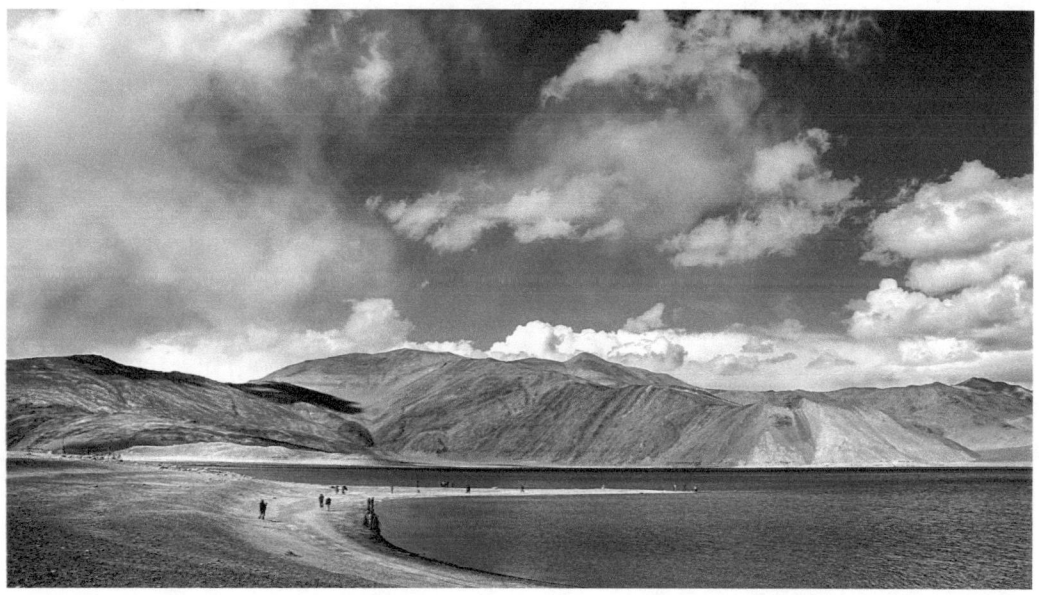

Pangong Tso!!! Tso means lake. The lake's water is transparent, dark blue-green coloured. You might easily count each multi-coloured stone accumulated on the bed of the lake through the transparent water. From morning to evening, the colour of the lake gets changed with transformation of daylight.

Spectacular and stunning colours like blue-sky blue-turquoise-violet-green play around with the glittering water throughout the day. At some times the water becomes colourless! In spite of being salty, the entire lake gets frozen in winter. On the ice-ground the army men play cricket with full vigour. During this time, Chanchengmo and Pangong mountain ranges stand as the walls of the lake, thus protecting from the chill wind coming from the other side. The colours of these ranges are also vibrant. Most of the times, the lake's water bears the shadow of mountain and the snow-white clouds, thus creating a multidimensional impact. Over the mountains, the sky of China peeps in. The sky and the blue water are the playgrounds of brown headed gulls. Fortunately, the border of two countries cannot restrict their free movements --- Sixty percent of Pangong Lake lies in Tibet and the rest is in India. In spite of being the storehouse of such stunning beauty, Pangong Lake also could not escape from the controversy and and filth of political war. Putting a question mark on Pangong's pride, the border of China and India cross through the lake tearing it apart. A place, 20 kilometres away from the line of control, is ruled by China. Nevertheless, India claims that place to be their own, this is a part of India, in the Indian map.

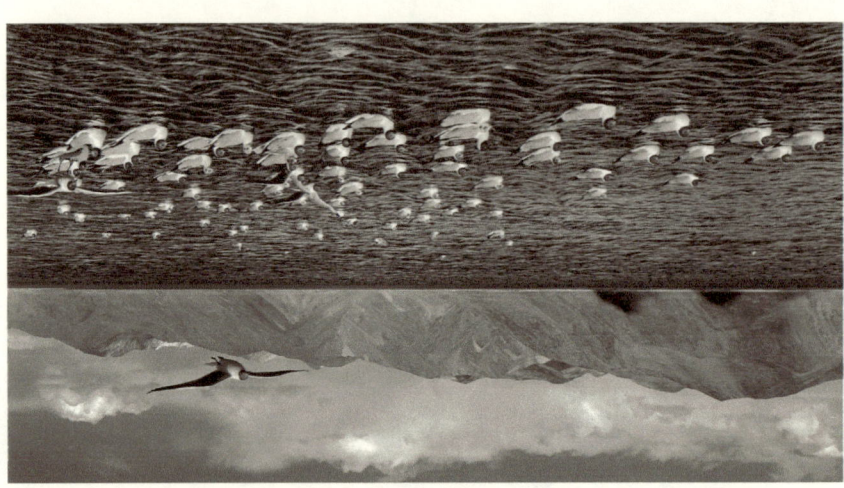

Chapter 29: The last words

Human beings have been running after Ladakh from ages in search of overwhelming beauty offered by the nature, blessings of Lord Buddha and touch of Tibetan culture. The message for peace as campaigned by Buddha, is echoed from the Monastery to Monastery, sky & air, flora & fauna, mountains & peaks, everywhere ... "Om Mani Padme Hum..." ("in dependence on the practice of a path which is an indivisible union of method and wisdom, you can transform your impure body, speech, and mind into the pure exalted body, speech, and mind of a Buddha...")

The harmony of this composed, cool and peaceful nature had been troubled by the smoke of ammunitions and sound of heavy boots of soldiers since ancient ages. Wherever I went, through the nook and corner of Ladakh, time and again a fundamental question came to my mind, almost every now and then. Probably nobody will disagree to the fact that a mere touch of this picturesque nature is capable of wiping out even a tiny spot of rivalry from anyone's mind. Right there, how can the people take lives, destroy, and demolish just by fighting over an imaginary line ---'BORDER'.

This is a plain and simple question! It might be more than easy to drag this argument by bringing in logics and counter logics. Standing alone in front of the huge and liberal nature, I asked this question to myself many a times!!! I could not generate any response from myself. The indestructible omnipotent nature, with all of its pride of vastness, remained unanswered as well....